C000172848

# BATH
## THEN & NOW

### IN COLOUR

JOHN BRANSTON & DAN BROWN

*This book would not have been possible without the vision of the original photographers, the dedication of the original collectors and the diligence of the present-day custodians of these images. Without their efforts, none of this material would be available to share in this way.*

First published in 2013

The History Press
The Mill, Brimscombe Port
Stroud, Gloucestershire, GL5 2QG
www.thehistorypress.co.uk

© Dan Brown & John Branston, 2013

The right of Dan Brown & John Branston to be identified as the
Authors of this work has been asserted in accordance with the
Copyrights, Designs and Patents Act 1988.

British Library Cataloguing in Publication Data.
A catalogue record for this book is available from the British Library.

ISBN 978 0 7524 6630 9

Typesetting and origination by The History Press
Printed in India.

# CONTENTS

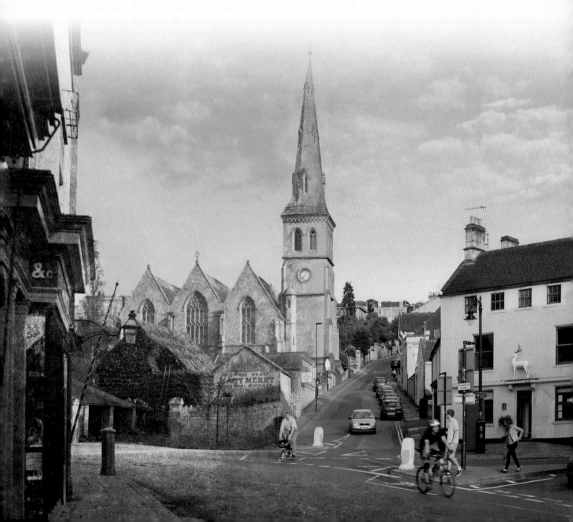

# ACKNOWLEDGEMENTS

It is easy to look through a large selection of photographs in a collection without thinking about the people who were responsible for taking them in the first place. The work of George Love Dafnis (1874-1967) and Lesley Green-Armytage (1911-2002) should be singled out in particular for their care in documenting the appearance of Bath in different periods. Their pictures demonstrate an obvious love for the city, as well as showcasing their skill as photographers. They have left an important legacy to be enjoyed by future generations.

Many of the present-day shots would have been impossible without the cooperation of the people of Bath – from shopkeepers, bus drivers, skateboarders and cyclists to buskers, builders and traffic wardens – whether allowing access to required vantage points, or agreeing to appear in the photographs themselves, they have made a valuable contribution to this book and we extend our thanks.

John would like to thank Jo and Alec Branston, who provided extensive moral and practical support throughout the researching and writing of the book.

Dan would like to thank Claire Hedley for help with proofreading and for her ankle-holding assistance when elusive vantage points were sought up various lamp posts!

Our thanks also go to Dr Amy Frost of the Bath Preservation Trust for providing access to its extensive library and archive, and to Dr Cathryn Spence for articles published in *The Bath Magazine* and the research they represent. The staff of Bath Central Library are also thanked for their support in retrieving maps and archive items in the course of the research undertaken for this book.

# ABOUT THE AUTHOR & PHOTOGRAPHER

John Branston is a Bathonian with a passion for local social history. His eye for detail has helped to locate and identify many photographs of the city and beyond for Bath in Time.

Dan Brown runs the popular Bath in Time archive of historical images. He is also a fine art photographer and has photographed many publicly owned oil paintings in the South West for the Public Catalogue Foundation.

# INTRODUCTION

Bath is well known as the Queen City of the West, an architectural jewel in the crown of Britain's built environment. It has been a magnet for visitors for centuries, if not millennia, initially due to its thermal springs, then for the draw of fashionable society and the stately architecture, which built – literally – on the qualities of the local stone. Later still, the Roman archaeology, which is still being uncovered beneath the streets and buildings of the city, has provided the basis for one of Bath's many excellent museums, which have in turn added to the steady stream of visitors. The aesthetic aspects of the city's natural and built environment have provided a beloved subject for photographers since the inception of photographic techniques, right up to the present day.

Many books written about Bath completely overlook the 'other side' of the city, namely that it is home to Bathonians, who identify with 'their' city because they – and their families before them – have built it, in both a figurative and a practical sense. Too often this sense of collective ownership is overlooked in debates about what constitutes the city's heritage and what, as a result, is or is not worthy of preservation.

The research for this book has brought into focus the extent to which Bath is, in any case, a city of constant change. Much of the historic 'Georgian' centre is actually of much later (especially Victorian or 1930s) origin and the fact that this still largely presents a harmonious whole is tribute to the largely uncelebrated architects of those times – some quite prolific – who truly understood the city and did not fear change.

Alongside the pictorial depiction of how Bath's built environment has developed, the images in this book provide some fleeting glimpses of the people and businesses that, collectively, have played a significant part in the making of Bath. Some, such as Stothert & Pitt, Evans Fish Saloon, Hayward & Wooster, or Duck, Son & Pinker, are easily recalled by many Bathonians; others would be lost to obscurity but for the work of the avid photographers whose images, whether by accident or by design, have helped create a visual link to many forgotten aspects of life in the city.

Bath presents many challenges – mostly pleasurable – to the modern photographer, as the beautiful setting, stunning architecture and honey-coloured stone all respond magically to the light. Compiling these modern photographs of specific locations proved especially tricky, however. Poor weather, combined with a rash of major building work, meant that what might seem a straightforward task ended up stretching over a three-month period as we waited for optimal conditions.

We have ordered the photographs in a sequence that allows the reader to walk easily between most locations. All of the old images have come from the online image archive Bath in Time, and are drawn from collections held at Bath Central Library and the Bath Preservation Trust, as well as from private collections. These form a small part of the extensive online collection of historical images that can be seen at www.bathintime.co.uk.

*John Branston and Dan Brown, 2012*

# KINGSTON PARADE (1923-4)

THIS OLD PHOTOGRAPH can be dated accurately by the building work in progress against the wall of the south aisle of the abbey. The extension to the abbey's facilities was first known as the War Memorial cloister, built to honour the fallen of the First World War. It later became the choir vestry and now serves as the abbey gift shop.

The palpable sense of history one feels today in the space between the Roman Baths and the medieval abbey could lead one to think that this is one of those places that the hand of time has not touched. It comes as a surprise to many to realise that, within the comparatively recent past, there was a huge 'hole in the ground' that was the Kingston Baths.

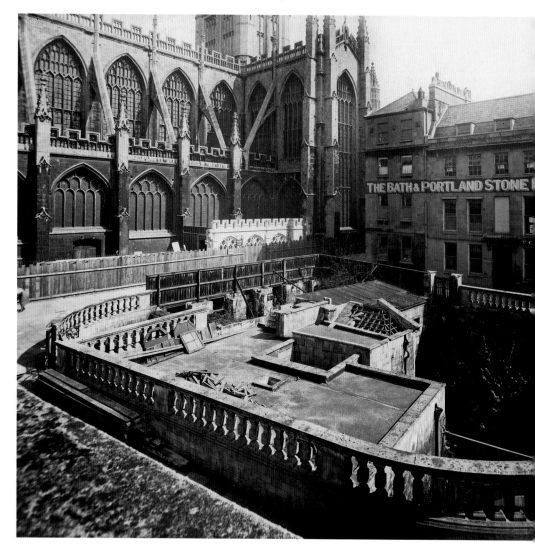

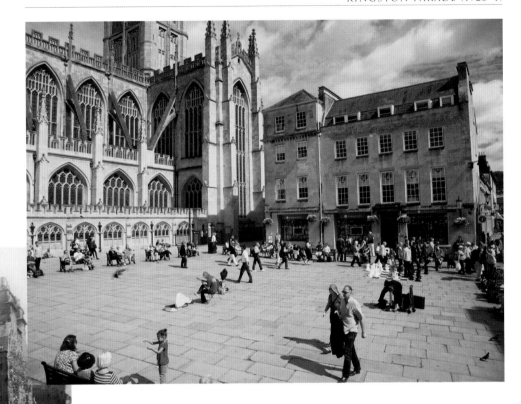

The 'Duke of Kingston's Baths' (after the landowner) were constructed here on the site of the west range of the abbey cloister in 1755, at which point the eastern end of the Roman Baths complex came to light for the first time. When this old photograph was taken, the baths had closed and were in the process of being demolished, making way for the complete excavation of the Roman remains.

In the background are the offices of the Bath & Portland Stone Firms Ltd. In 1887, seven separate Bath stone companies had formed a conglomerate and then taken over the Portland stone quarries two years later. The company remained here until the 1960s. In fact, this view was nearly the subject of dramatic visual change in 1966 when the company proposed a new four-storey office block to replace Kingston Buildings. The design was very much 'of its time' and had it been built (and survived to the present day!) would be viewed as nothing but a disaster for the setting of the abbey. In the event, the proposal fell at the final hurdle of an inquiry after it had been recommended for approval by the planners. Kingston Buildings were reprieved and became temporary home to the city's planning department.

Note also 'T. Crisp – Estate Agent' in the offices now home to the Tourist Information Centre; they were a precursor to Crisp Cowley, who now reside just across the street.

Today the space is an unofficial stage for the city's buskers and a favoured, central spot for visitors to the city to picnic, sit in the sunshine, and take a break between various tours and museum visits.

# ABBEY GREEN (C. 1925)

THE ORIGINAL ABBEY Gate was not part of the city wall but an entrance into the monastic precinct at the back of the Bishop's Palace. It was sited at right angles to this later addition, looking down Abbey Gate Street towards Stall Street.

   The old Abbey Gate was removed in the eighteenth century, leaving a hinge attached to the front wall of the famous Evans Fish Saloon, which was on the top corner of St James Street South. The hinge remained on the frontage until the building's demise in 1973, when it was replaced by the new Marks & Spencer premises. The well-known retail chain added the new archway to the bottom corner of Abbey Green, naming it St Michael's Arch after its house brand. With its old premises having disappeared to make way for Marks & Spencer, Evans moved into the building facing down Abbey Gate Street and was a fixture here until recently.

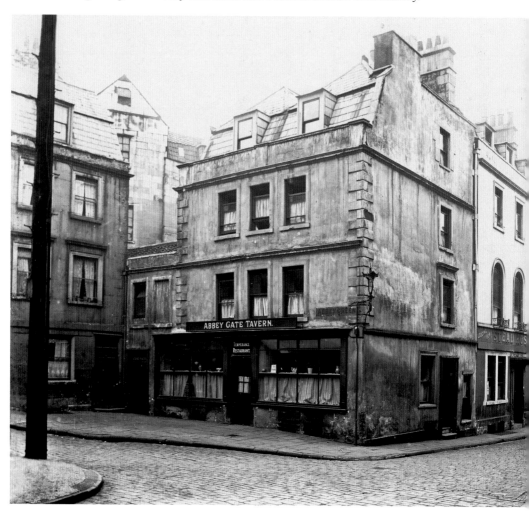

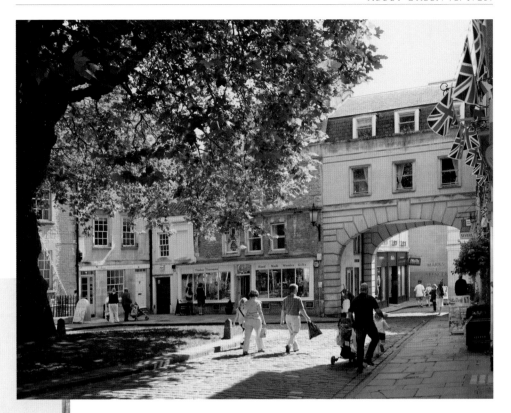

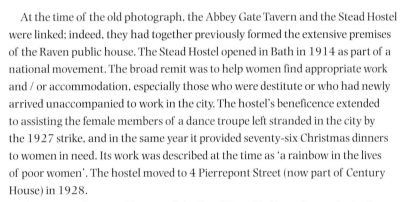

At the time of the old photograph, the Abbey Gate Tavern and the Stead Hostel were linked; indeed, they had together previously formed the extensive premises of the Raven public house. The Stead Hostel opened in Bath in 1914 as part of a national movement. The broad remit was to help women find appropriate work and / or accommodation, especially those who were destitute or who had newly arrived unaccompanied to work in the city. The hostel's beneficence extended to assisting the female members of a dance troupe left stranded in the city by the 1927 strike, and in the same year it provided seventy-six Christmas dinners to women in need. Its work was described at the time as 'a rainbow in the lives of poor women'. The hostel moved to 4 Pierrepont Street (now part of Century House) in 1928.

The gateway between Evans and the Stead Hostel led into the precincts of the Weymouth School, which is the large building visible in the background. The school was built in 1897 to replace earlier school buildings on the site of Weymouth House – once the historic Bath residence of the Thynne (Viscount Weymouth / Lord Bath) family.

The recent trend towards the removal of render from Georgian façades, leaving ashlar window architraves standing proud of the stonework, is today in evidence on numerous properties in Abbey Green. One such is the popular guest house Three Abbey Green, surely the most central place to stay in the city.

# STALL STREET (1930s)

STALL STREET IS one of the ancient streets of the city, appearing on the earliest known maps and leading from the very centre of the city, and the site of the church of St Mary de Staule, down the side of the abbey precinct to the southern city gate and Old Bridge. Union Street, in the distance, is distinctly modern by comparison, having been created as a result of the Bath Improvement Act of 1789; the same Act also caused Stall Street to be widened in 1805. The street has been considerably remodelled in more recent times, most notably in the 1930s.

The tram coming towards the camera is bound for Oldfield Park; the railway bridge in the vicinity of the Green Park Tavern meant that only single-decker trams could be used on this route. Today, a combination of the one-way traffic system and a deliberate lack of parking in this sector of the city means that Stall Street is now usually dominated by pedestrians.

Stall Street is now very much the domain of the 'high street chain' and the directories of the time show that, even in the late 1930s, it was already home to a number of household names, such as Burton's (still in the same position today), Halford's, Woolworths (right-hand side, with the 'W' in the panel) and Marks & Spencer (also on the right). The latter two traders later moved to

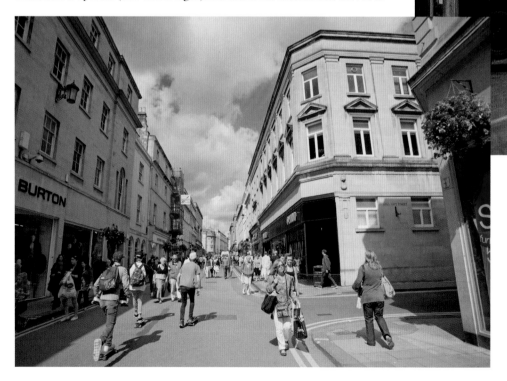

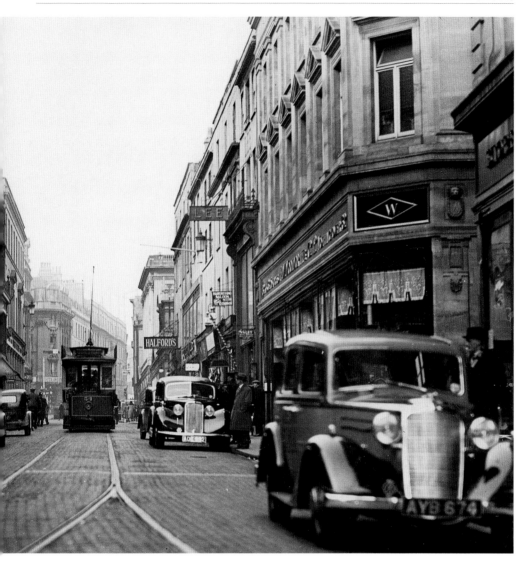

purpose-built premises between Abbey Gate Street and New Orchard Street, resulting in a wider, remodelled Abbey Gate Street and the complete removal of Weymouth Street, which once ran along the northern side of St James' Church.

The old photograph also shows a number of traders that are now all but lost to the memory. Charles Cowley's confectionery shop was next door to Burton's, with Gilbert's Billiard Rooms above. Then came the Lamb Hotel, once a significant coaching inn dominating this plot between Bilbury Lane and Stall Street but later broken up and reduced to this single premises. The current Lamb & Lion in Lower Borough Walls was once part of its stable block.

Beyond Beau Street was Foster's – there from the 1920s until comparatively recently. Lee's ironmonger disappeared soon after this photograph was taken, as did the trams.

# LOWER BOROUGH WALLS (1956)

EARLY MENTIONS OF St James' Church refer to the small medieval church which stood on this site just inside the southern gate of the city. It was built here in 1279 to replace a church on the east side of Abbey Green, hence its parish stretched right up to the walls of the abbey. The church was rebuilt in the 1760s but retained its earlier short, castellated tower. Then in 1848 the west end (seen here) and the tower were completely remodelled into what became its final form. The later tower, with its cupola, was a fixture on many early postcard views and the building itself was a dominant edifice in the southern part of the city, with many thoroughfares leading around its walls in what was then a slightly more labyrinthine structure of streets in the lower part of town. The gabled house in one of the 'lost' streets, St James Street South, can be glimpsed in the distance.

The church suffered catastrophic damage in the German air raids of April 1942 and lingered as a burnt-out shell for a further fifteen years before its ultimate demolition in 1957.

The parish having been subsumed into a single benefice with the abbey, the dedication of St James was transferred to what is now St Philip & St James' Church on Odd Down (these saints are often paired due to the shared feast day on 1 May). The sale of the city-centre site was used to fund the rebuilding of that church in the far reaches of Lyncombe & Widcombe parish. The stone cross in the Odd Down church is also made of stone from St James', although most of the masonry was cleared and unceremoniously deposited in Lyncombe Vale.

The name of the church lives on in James Street West which, despite the long absence of St James Street South, still maintains its distinguishing suffix. The church's old hall is now the Chapel Arts Centre.

Today the view takes in the twenty-first-century frontage of the new Southgate development on New Orchard Street, the 1930s corner of Stall Street, the 1960s edifices of Northwick House and the former Woolworths block (now M&S). The only Georgian remnant in this view is the Lloyds Bank building; at the time of the old photograph, this was the stationery shop belonging to Mrs Louis (blue) and Newman & Sons hardware shop.

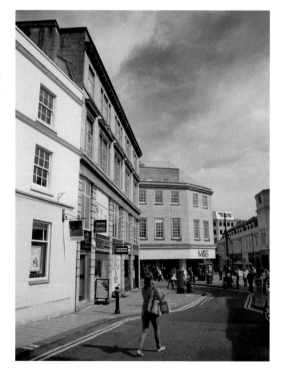

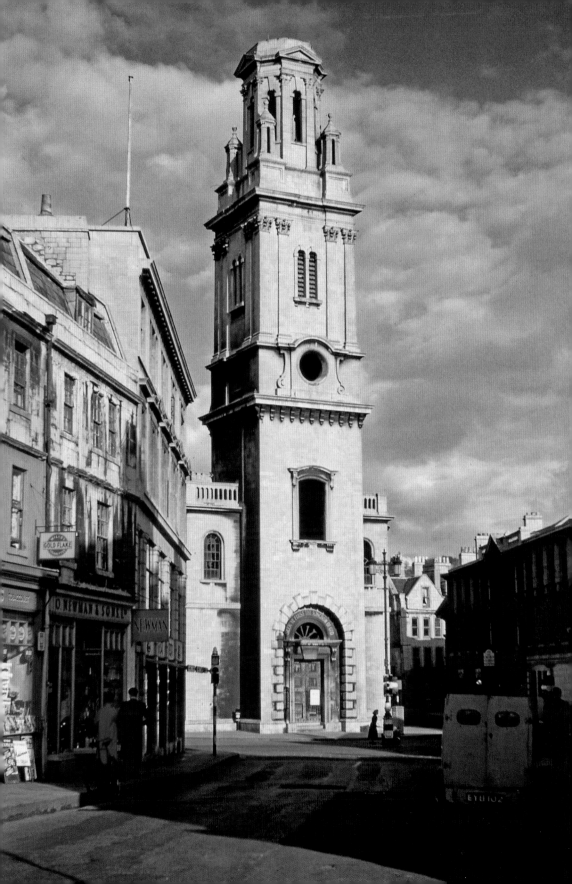

# NEW ORCHARD STREET
# (20 JULY 1971)

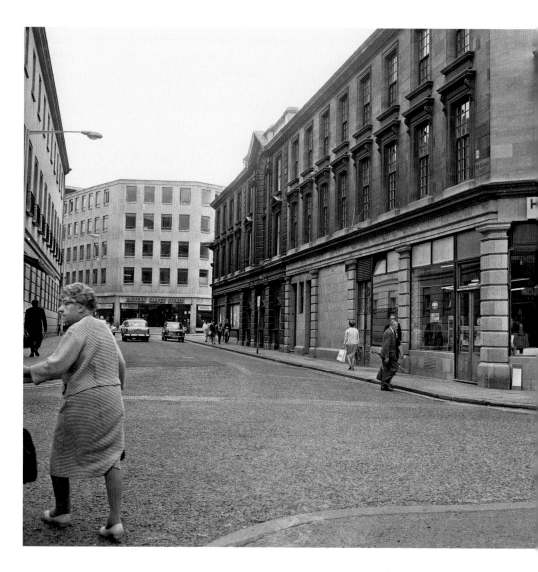

THIS VIEW ALONG New Orchard Street is taken from a standpoint close to the site of the old west door of the church of St James. The old city wall ran along the alignment of the road, with the South Gate just out of view to the right and the Ham Gate roughly in the position of the cars in the distance.

The edifice of Northwick House towers in the background. This was the first of the 1960s buildings in this part of the city and its role as an enabler for other modern buildings in the southern part

of the centre has been argued. In *The Sack of Bath*, a contemporary documentation of wholesale redevelopment, Adam Fergusson cites the 'method' by which areas of Georgian buildings were separated from the context of the city-centre setting. It then became easier, so the theory went, to 'mop up' the rest and it is true that the Woolworths block (here on the left), which came next, drove a massive wedge across the lower end of the city. It is also true, however, that the bus station in Railway Place – now gone – had already been a fixture for ten years at this point.

The Woolworths block was singled out for specific criticism by Fergusson and pictured in *The Sack of Bath* in stark juxtaposition with the abbey, photographed by Lord Snowdon from Beechen Cliff at the time when its 'built by the mile, cut off by the yard' frontage had gained greater temporary prominence due to the demolition of the Southgate area ahead of the 1970s development.

The southern side of New Orchard Street (here on the right of the old photograph) had already been remodelled in the 1930s, but this was essentially a treatment of the street frontage only, with older houses remaining just around the corner in Southgate Street and Philip Street. Behind these were yards and workshops that included the central abattoir, this having moved to premises in Philip Street from its previous site behind the Guildhall.

So the building that was home to Holloway's lasted only forty years and its successor only another forty. Today we can only wonder whether the bizarre jumble of pseudo-architectural features that make up the new Southgate will stand the test of time any better. Or was the plastic bunting hung in the new St Lawrence Street for the Queen's Diamond Jubilee, which faded after a week in the sun, a metaphor for attempts to build on this site outside the old South Gate?

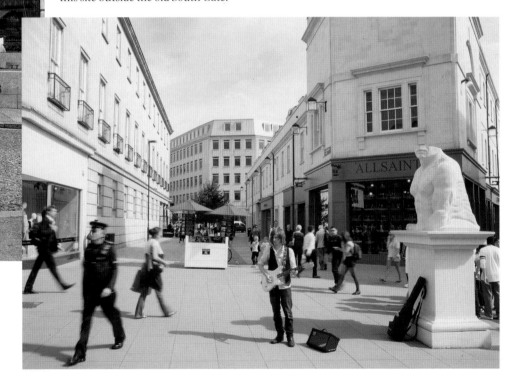

# MANVERS STREET
## (4 MAY 1901)

AT THE HEART of this amazing scene in Manvers Street in May 1901 is a band of soldiers returning home victorious at the end of the second Boer War.

They had started for the front in South Africa in February of the previous year. Following a call-to-arms at the Guildhall in January 1900, men from the Somerset Yeomanry were joined by reservists from the Bath Volunteers. A huge send-off was given in the form of a special service at Bath Abbey, attended by a huge congregation and all of the city's dignitaries. The following day, the troops assembled at the Drill Hall on the Lower Bristol Road for parade, photographs and final words of encouragement from Colonel Clutterbuck, who led the Bath Volunteers and whose standing as a commanding officer was enhanced by the fact that his father had served in the Charge of the Light Brigade.

Each soldier received a pipe and a packet of cigarettes and there were several other presentations, both to the group and to individuals, sponsored by the major Bath businesses of the time, some of whom were the employers of the men taking their leave. They then marched through thronged streets, via an address outside the

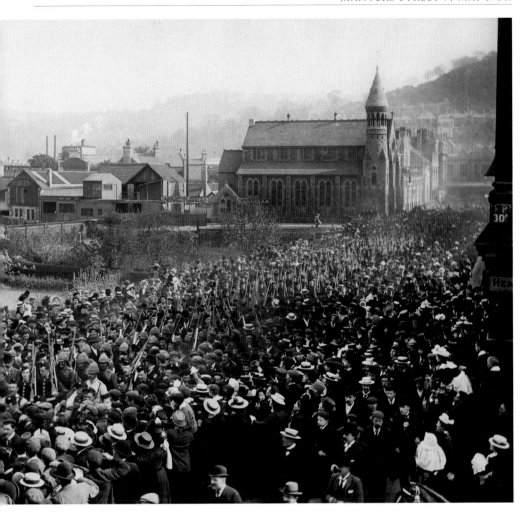

Guildhall, to the railway station and travelled via Taunton to the front, arriving in South Africa over a month later.

The parade pictured here centres on just thirteen returning soldiers – probably the tanned faces under the pith helmets in the centre of the picture. Three of the original twenty-six had previously been invalided home; two were casualties of a stomach bug; with eight others left behind, still invalided in hospitals in South Africa. The other men in uniform – numbering nearly 600 – are the welcoming party formed by the remainder of the Bath Battalion of the Volunteers, with numbers swelled further by men from the Brislington and Keynsham companies. Here they are en route to a reception at the Guildhall, after which they retraced their steps of the previous year to the Drill Hall where they were reunited with family and friends.

Today, the 1966 police station and a public car park have replaced the Ham Garden, itself a remnant of the Abbey Orchard area. The riverside site, now occupied by the Royal Mail sorting office and the former St John's School buildings, was once a hive of industrial activity dominated by a saw mill and timber yard.

# SOUTHGATE STREET (C. 1975)

IN 1971, A huge area in the south of the city was cleared to make way for the new Southgate development. The whole area between Southgate Street and Kingston Road was flattened and replaced with the modern shopping centre, which is captured in all its glory in the old photograph.

The guiding principle behind the plan was summed up by the city planner of the time, Howard Stutchbury, who said he could see no reason why the citizens of Bath should not enjoy the same level of amenities as the inhabitants of Birmingham. With shops at various times including branches of Boots, John Menzies, David Greig, Littlewoods, Tandy, Millets and Oswald Bailey, plus some local independents (e.g. Eric Snook's), it has to be said that the shopper was well catered for, even if the architectural purists were not. Chief architectural writer for the *Bath Chronicle*, Bryan Little, concluded that there was 'little to tempt the shopper as they scurry from multiple

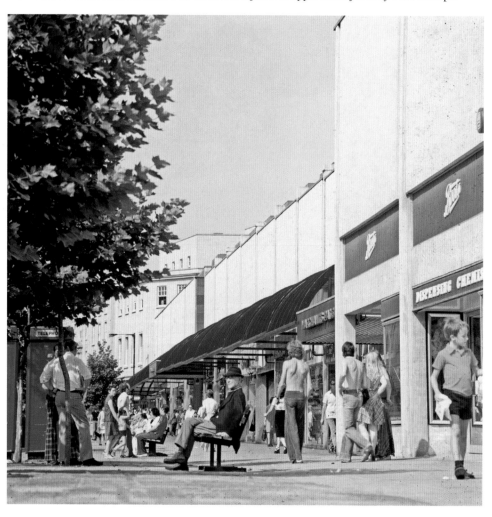

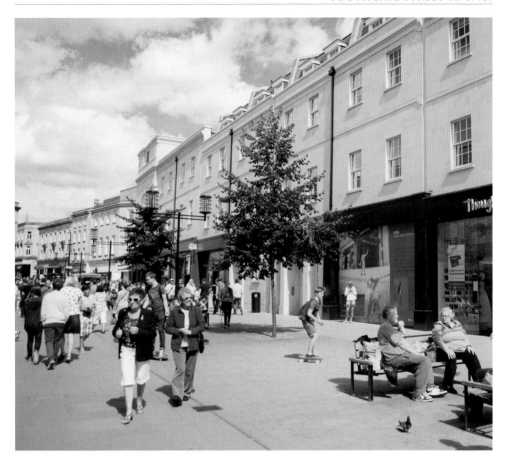

to multiple', although he did praise the scale of the buildings and the fact that views to Beechen Cliff were not obscured.

The wider architectural press also condemned the scheme and, at the time when Bath sought a replacement for Stutchbury, stated: 'We must all hope that the person who gets the job has the wisdom never to let the city suffer the indignity of a Southgate Centre again ...' They added: 'Architect Owen Luder has shown how little understanding he has of the place in which he has built.'

The *Chronicle* at the time lampooned the critics somewhat with a futuristic cartoon set in the year 2124, in which conservationists defended the (by then historic) development – still with Littlewoods on the corner! – from twenty-second-century developers wanting to build a modern commercial megastore.

As it turned out, the Luder-designed centre did not have to wait anywhere near 150 years to be the subject of commercial redevelopment. When it was demolished in 2007, no one campaigned to save it; rather the opposite! The phased opening of the new 'SouthGate' centre began in November 2009. As Bryan Little commented in 1974: 'Bath deserves modern architecture which is a contemporary evolution of classicism.' He was clear that Luder's Southgate was not it. The latest iteration, with its massive-scale, monolithic blocks of repetitious, computer-generated pseudo-architectural façades built to emulate – of all things – the Woolworths block to the north, is surely not it either.

# SOUTHGATE STREET / DORCHESTER STREET (1933)

THE FIRST DECADE of the twenty-first century saw a sustained battle to save Churchill House; a battle that was ultimately lost. Here we can see Churchill House, known at its opening as the 'Electric Light Station Offices' and later 'Electricity House', nearing completion at the hands of Hayward & Wooster, a local builder once headquartered in Walcot Street, who built everything from the Guildhall extensions to the 1906 pinnacles on the abbey.

Built on the site of the old Full Moon public house, the building's name changed around the time of Churchill's death, when the new bridges across the river were constructed and also so named. But when time was called on the unpopular 1960s / 1970s development between

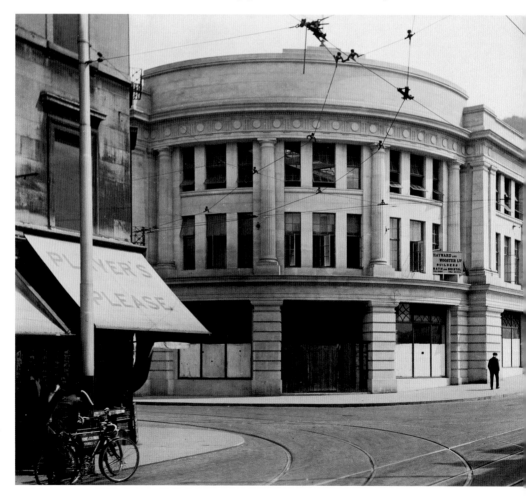

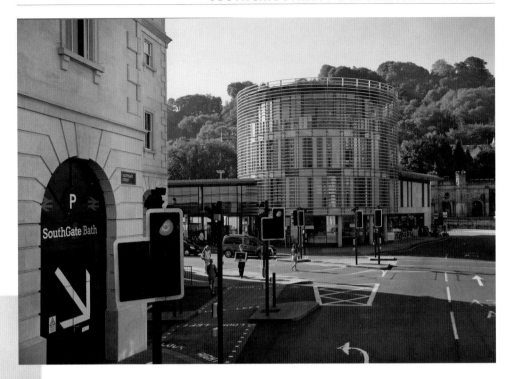

Southgate Street and Manvers Street, the site of Churchill House was included in the area for regeneration and earmarked for a new bus station.

Notable architectural lobby groups, including the Georgian Group, the Ancient Monuments Society and the Twentieth Century Society, rallied with words of support for a building which typified a 1930s interpretation of classical elements and which they felt had therefore earned the right to survive the wholesale redevelopment of Southgate and Dorchester Street.

Campaigners tried everything to save the building. They attempted to get the building listed, they invoked evidence for the possible proximity of an unexploded Second World War bomb in the riverbed, and they submitted drawings showing how the façade could be retained as part of the new bus station. The battle was lost, however, and the new bus station, devoid of architectural merit but a somehow fitting accoutrement for the new SouthGate development, was erected in its place. Now, just a few years later, there are already public discussions about how the disastrous traffic situation in Dorchester Street – caused in part by the presence and design of the new bus station – can be mitigated.

The old photograph shows a couple of men standing outside Howe & Sons at the bottom of the old Southgate Street, and a bicycle delivery agent from Home & General Stores stands astride his bicycle. Note also the alignment of the Old Bridge with Southgate Street, and the old houses in the Holloway area beyond the railway viaduct.

It is interesting to think that in the intervening period between these photographs the Southgate area has been razed to the ground twice, and one wonders how long it will be before it happens again.

21

# OLD BRIDGE, LOOKING EAST (1956)

A BRIDGE HAS existed on this site since at least the thirteenth century. It once featured a castellated gateway at the southern end and a chapel to St Lawrence on the bridge itself, but these had disappeared by the time the bridge was altered in the 1750s. It was altered again in the 1840s and 1870s, with cantilevered iron walkways added, with the aim of keeping pedestrians out of the road. It was demolished in 1964 and replaced by Churchill Bridge.

Buildings from Claverton Street and Lower Bristol Road once adjoined the southern end of the bridge, with a pub called the Angel opposite the bridge itself (hence the nearby remnant of Angel Place). But in 1840 Brunel had driven his railway through the area on a massive viaduct and embankment which stretched all the way from Bathwick to Twerton, crossing the river on

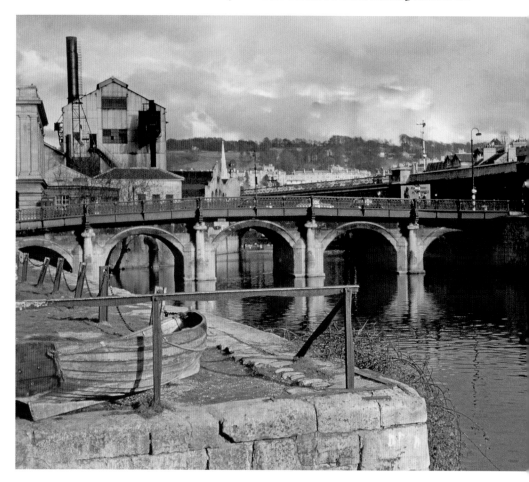

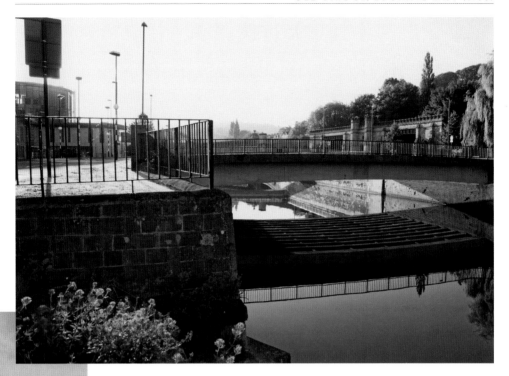

a skew bridge just upstream of the Old Bridge. At the point where the railway viaduct formed the backdrop to the vista down Southgate Street and over the Old Bridge, Brunel treated the viewer to a Gothic showpiece, complete with turrets and battlements. Archways either side of the embattled centrepiece led through to Claverton Street and Holloway.

Shortly thereafter, Widcombe police station took up residence in the part of the viaduct between the turrets, where there is still a large studded door. This was considered a strategic placement as the Old Bridge and Lower Holloway were areas in which certain types of petty crime were rife, and the forays of petty criminals into the city could now be more easily monitored.

Dominating the left-hand side of the scene is the coal-fired power station that was built in Dorchester Street to cater for the demand for electric lighting. Private residences adopted the new technology first, but when the city's new electrical street lighting system was switched on in 1890, it was the most extensive in the country. The power station was expanded westwards in the 1920s (at which time the city electrical engineer was a Mr J.W. Spark!) and the new station supplied electricity into Wiltshire as far as Chippenham and Devizes.

In 1931, the new offices and showroom completed the frontage of the works onto Dorchester Street. Although this extension was not yet necessary, the Corporation was in a position to bring the work forward as part of a wider drive to relieve local unemployment.

# OLD BRIDGE,
# LOOKING WEST (1894)

SEEN FROM THE upstream side, this is the Old Bridge that was demolished in 1964 as part of the flood-control measures. The bridge itself had long proved an impediment to the free flow of floodwater, exacerbating an already difficult situation. The replacement road bridge was built somewhat downstream of the Old Bridge, and what is visible in the modern photograph is the footbridge; both were built as single spans, to allow the water free passage. The fact that neither is on the alignment of the old Southgate Street makes a nonsense of the architecture of Brunel's viaduct in both a functional and an aesthetic sense.

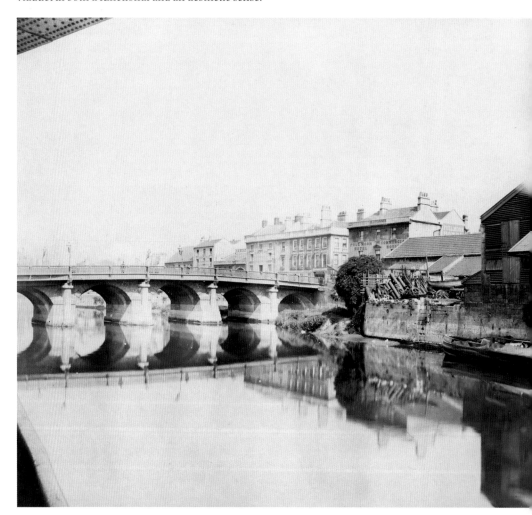

On the right of the old picture, the area known as Kingston Wharf –
featuring the premises of Gerrish & Co., with their horse-drawn barges – has
changed beyond all recognition. It is now home to the relatively new bus
station, controversial both for its could-be-anywhere design and for the fact
that it replaced Churchill House, which some considered should have been
retained. There are still others who would argue that Bath does not need a
central bus station at all, especially one whose design dictates that arriving
rail passengers must walk the furthest possible distance to the ticket office,
and that Dorchester Street traffic has to be brought to a standstill in both
directions each time a bus emerges.

But Churchill House will fade into history, just as its predecessor did. No one
now bemoans the loss of the Full Moon public house, although it was once a
'fixture' on the town side of the Old Bridge and home to numerous societies,
including the Anglers Association and the Bath Butchers Association. Having
existed as a pub since around 1700, and as the Full Moon since around 1750,
it was demolished along with other premises in Dorchester Street and on
Kingston Wharf to make way for the new Electricity House in 1931.

The electricity company premises that expanded to include the construction of
Churchill House grew from the initial coal-fired power station, whose chimney
towers over the scene in the old photograph.

It is the long exposure time used for the early photograph that gives the surface
of the river an uncharacteristically smooth appearance.

# CLAVERTON STREET (1964)

IN 1966, THE bulk of the housing in Claverton Street was cleared in preparation for the creation of a relief road from the Churchill Bridge area round to Pulteney Road. This stunning old photograph, taken from the footbridge behind the railway station, offers a glimpse of how this eclectic row of shops, pubs and houses lined up between Claverton Street and the river. The street originally ran all the way along to the Old Bridge, with the oldest buildings at that end, but the Great Western Railway (GWR) sliced through it in 1840.

One of the more notable properties in Claverton Street was the Cold Bath House, fed by a spring on the site and recommended by the famous Dr Oliver (of biscuit fame). This was at No. 26, just out of this picture.

The red sign for George's Beers denotes the presence of the Coopers Arms, whose skittle alley protruded to the rear with a clubroom above. Another pub – the Claverton Brewery – was four doors further along to the right.

On the south side of Claverton Street, below the church, was Lyncombe Place and the unusual Bue Cottage. Much of the detail of the area – and especially of the Cold Bath House and Bue Cottage – was captured by the pen of Peter Coard, who spent thousands of hours recording details of buildings around Bath as they faced the bulldozer; sometimes (as in the case of Spring Gardens House), a note in the margin states that he was drawing as he watched the demolition take place. These drawings were published in the *Vanishing Bath* series and are now held by the Building of Bath Collection.

It's easy to lament the loss of such an eclectic mix of buildings, which were truly a significant part of the city. But the choices faced by planners who, at that time, were under major pressure to cater for increased traffic flows, were by no means easy. At least we have a case study in what happens when the needs of the car are given priority over all else. The trees planted along the roadside have now reached a degree of maturity that visually screens the road, but it still cannot be described as anything other than an urban motorway. This is a glimpse of what the Buchanan Plan would have delivered through Walcot, Charlotte Street, Bear Flat and several other places, in order to facilitate the free passage of the motorcar.

Only St Mark's Church remains visible as a point of reference. The church closed in 1972, perhaps due to the clearance of a portion of its catchment area.

# VIEW FROM
# BEECHEN CLIFF (1863-7)

THIS EARLY VIEW can be accurately dated by the appearance of St John's Roman Catholic Church in South Parade, which was built in 1863 but did not have its 222ft spire added until 1867.

The Ham Gardens are in evidence on the Abbey Orchard site, on the eastern side of what is now Manvers Street. John Wood the elder had planned to build in this area as early as 1730, but his plans were widely criticised and it was nearly a decade later that he produced plans for a 'Royal Forum' development, intended for this site. North and South Parades represent the only parts realised. It was much later that a further revised plan for 'Kingston Square' led to the building of the west side of Pierrepont Street, but this scheme did not reach completion either.

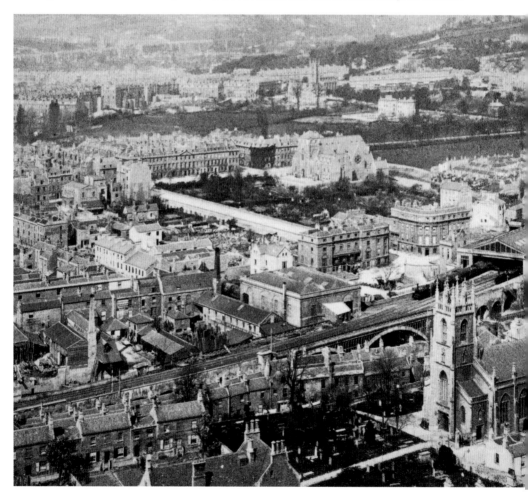

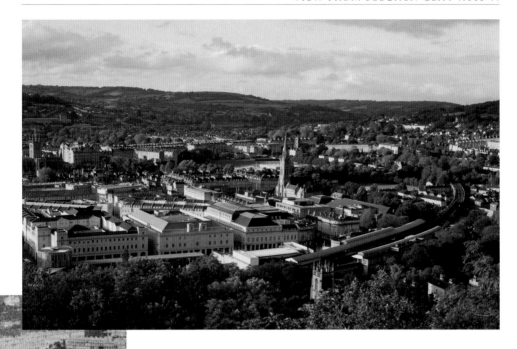

The railway and its station provide another focus of interest. The broad-gauge rails are still in evidence (replaced with standard gauge in 1892) as is the roof (removed 1897). The goods yards and sidings can be seen at either end of the station. Later, coal would be brought here to feed the electricity station, which arrived in Dorchester Street in the 1890s. The original southern station entrance, as seen in this old photograph, has recently been reinstated along with its canopy.

Also part of the railway is the old wooden skew bridge, which can be seen here. This was quite a feat of engineering, given the oblique crossing of the river that necessitated a 164ft single span to cross 80ft of river. This wooden structure was replaced in 1878 after the tragic collapse of the nearby footbridge under the weight of hundreds of visitors to the Bath & West Show (above Bear Flat), which meant that the railway company understandably lost faith in wooden bridges.

The old photograph also shows something of the relative isolation of the railway station, which required the building of Dorchester and Manvers Streets to connect with the existing street network. The Royal and Argyle hotels were built to provide a starting point for classical terraces that never materialised.

While the classic Victorian villas in St Marks Road presented a gleaming white appearance when new in the 1860s, the new SouthGate development now waits for the effects of weather and various pollutants to imbue it with the famous mellow honey colour.

# 'RALPH ALLEN'S ROW' (1966)

RALPH ALLEN DRIVE was originally a private drive for Prior Park for its entire length down to the area in the photograph. The Dolemeads Gate was situated here, between the White Hart and these cottages. The lower third of the road up to the gates of Abbey Cemetery was first made public, before the eventual opening of the entire thoroughfare as an access to Combe Down. The Drive was also the route of the famous railway carrying stone from Allen's Combe Down mines to the wharf on the Avon, and it was probably for workers at the wharf that these buildings were originally erected.

Advancing nearly 150 years to 1971, the row was in such a state of dilapidation that it was declared unfit for habitation by Bath Corporation. Appurtenances to the rear of the buildings were demolished and the cottages themselves had their doorways and windows stopped up with breezeblocks. Then came plans to widen the road at this point and the houses were earmarked for demolition, along with two cottages at the southern end that ran perpendicular up the hill. One of these was called 'Good Hope' and a *Chronicle* article of the time was called 'No Hope for Good Hope'.

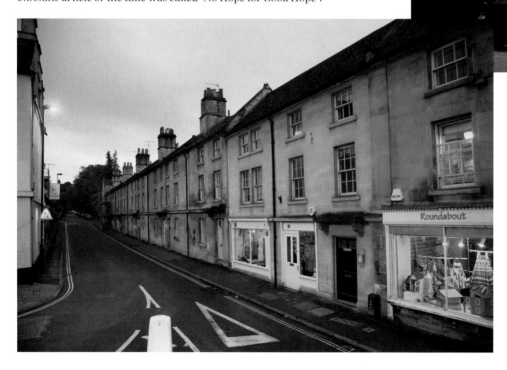

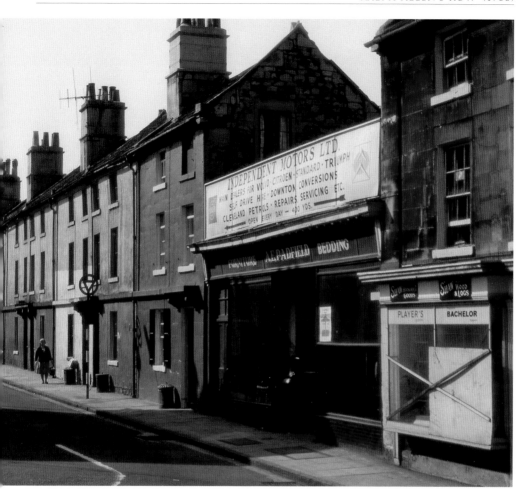

Peter Coard, meticulous recorder of buildings under threat of demolition, got to work drawing details of the buildings but, together with his wife Ruth, campaigned in parallel for their preservation. An appeal was launched at the highest level but the Department of the Environment ruled that clearance orders, once issued, could not be rescinded.

It was research carried out by Ruth that ultimately led to the salvation of the houses. She noted architectural similarities between these buildings and the Yorkshire vernacular with which Allen's architect, John Wood senior, would have been familiar; Wood spent his formative years in Yorkshire before returning to Bath in 1727. The 1730s date of construction also fitted with a document pertaining to a 1737 Widcombe parish survey, which described 'ten houses by the withy bed, property of Ralph Allen, Esq'. The weight of evidence was sufficient to demonstrate provenance and to ward off the bulldozers.

Restoration of the properties began in 1980, including façade cleaning and the infill of the old shop premises as a full height continuation of 'Allen's Row'. People began moving back into the houses in 1981, and in 1985 the renovation work won a Conservation Area Environment Award.

# WIDCOMBE HILL (1853)

DOMINATING THIS SCENE at the foot of Widcombe Hill is the church of St Matthew, built in 1847 as Widcombe New Church by George Phillips Manners, city architect, to relieve the tiny old parish church of St Thomas à Becket.

A rare glimpse is afforded of Widcombe Wood & Coal Wharf, run at this time by Mary Merry and later by the Stockden family after George Stockden married into the family. The stone-built wharf buildings survived until 1968 and were captured by Peter Coard prior to their demolition. They made way for the Widcombe Social Club, visible in the current photograph, which is now itself earmarked for demolition and redevelopment.

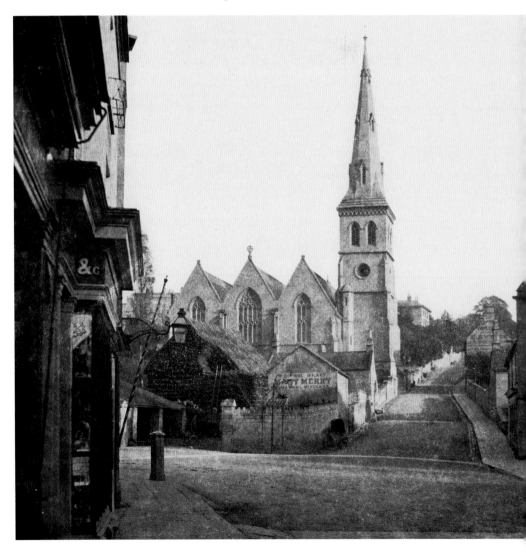

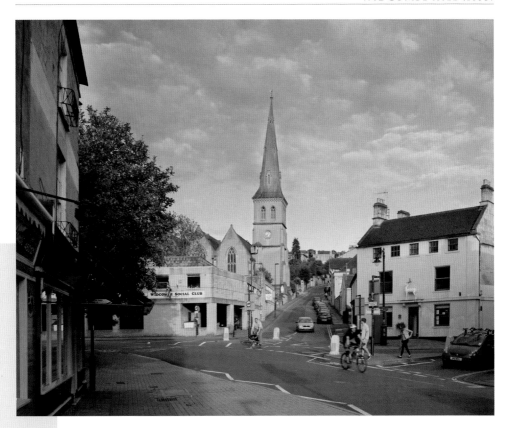

Coard also captured the house across the road, seen here in the distance with its gable end proclaiming Daniel Butler's Widcombe Nurseries, which operated from an extensive site behind the White Hart. Daniel Butler became a nurseryman following a stint as head gardener at the villa that became the Bath Spa Hotel. Butler's house and business was taken over by the Payne family, and remained with them for many years prior to being replaced with a bland block of flats called Glebe House.

The White Hart public house still trades from the same spot. William Brett was landlord between 1851 and 1855. The carved wooden animal over the door was an opportune acquisition at the time of the closure of the famous coaching inn of the same name in Stall Street. The hart famously disappeared shortly after being restored in the 1990s and was found, *sans* head, in the stream in Prior Park Road. It was given a new wooden head and a set of real antlers and was 'rededicated' by Lady Margaret of the Natural Theatre Co., whose headquarters is the former Widcombe Reading Room & Institute (1886), just up the hill from the pub.

The traditional red and white barbershop pole protruding from the shops on the left denotes John Hibberd's premises at No. 6 Coburg Place. This address was once a row of shops, lining this corner right around to the Ebenezer Chapel church rooms. Most of Coburg Place was demolished in the 1960s and is now the site of the Baptist church car park, but one tiny shopfront still adjoins the church buildings today.

# KENNET & AVON CANAL, WIDCOMBE (1965)

THE OLD PHOTOGRAPH shows the smouldering remains of part of Waterloo Buildings, cleared to make way for Rossiter Road, whose concrete bridge over the canal is plainly evident in the modern version. This is the scheme that also required the clearance of Claverton Street, further to the west. The scheme was long in the planning and costs more than doubled before it was finally begun, rendering it even more controversial than it already was.

The road has been a partial success, but the residual westbound traffic through Widcombe Parade is still a problem, and calls to make Rossiter Road two-way are as loud now as they have repeatedly been since it was built.

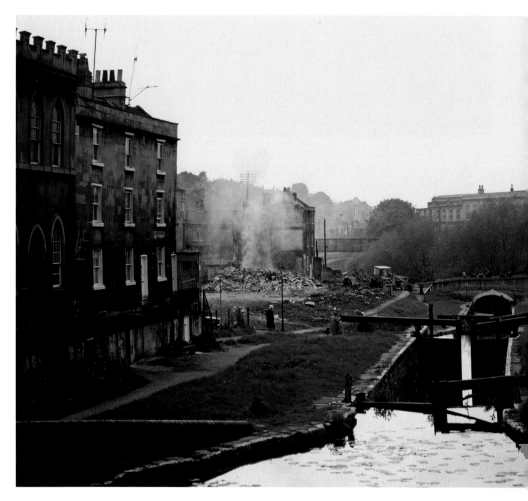

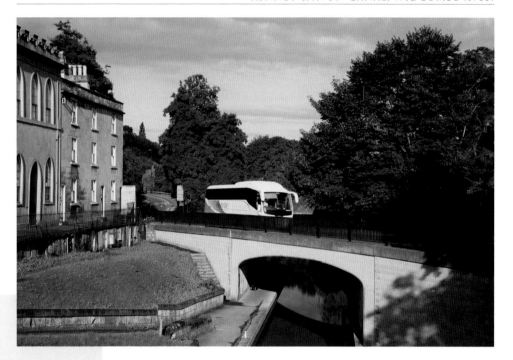

Thimble Mill was a pumping station which once pumped water up to the basin at Widcombe Wharf. It was briefly an upmarket restaurant attached to the hotel (now a Travelodge), built on the site where originally a leisure-oriented marina was proposed.

Attempts to screen the road with greenery now also obscure the railway station, where the signal box sat astride the roof until 1968. A significant effect of the road improvement on the canal was the eradication of Chapel Lock (in the middle of the old picture), which meant that a remodelling of the next lock up was required. This resulted in what is now called 'Deep Lock', the second-deepest lock in the country.

The old photograph was taken from the old Chapel Bridge, whose demolition caused a delay in building work in 1975 when it transpired that the consent of the Environment Minister was required.

The Kennet & Avon Canal opened in 1809 but suffered a decline after the opening of the Great Western Railway in 1840 and subsequent purchase of the canal by the railway company in 1852. In 1926 the company sought permanent closure of the navigation to mitigate the cost of its upkeep after decades of making a loss on the canal's operation. Bath Corporation began discussing various uses for the canal, including a roadway (of course!) and allotment gardens. In the end closure was averted, but it effectively came in the 1950s when parts of the canal fell into total disrepair. The restoration of the Kennet & Avon Canal, culminating in its reopening in 1990, was a major achievement and of huge tourism and leisure benefit to Bath.

# MIDDLE LANE, NOW BROADWAY, DOLEMEADS (C. 1906)

THIS OLD PHOTOGRAPH documents the early stages of a phase of major improvement work in the Dolemeads area of the city. Effectively a 'finger' of land between the River Avon on one side and the Kennet & Avon Canal on the other, the Dolemeads became known for its slum housing and lack of general social provision. It had this in common with the Avon Street area, and for largely the same reasons; the regular flooding of the River Avon hit the low-lying Dolemeads hard, bestowing repeated misery on its inhabitants and also leading to the area gaining its nickname of Mud Island.

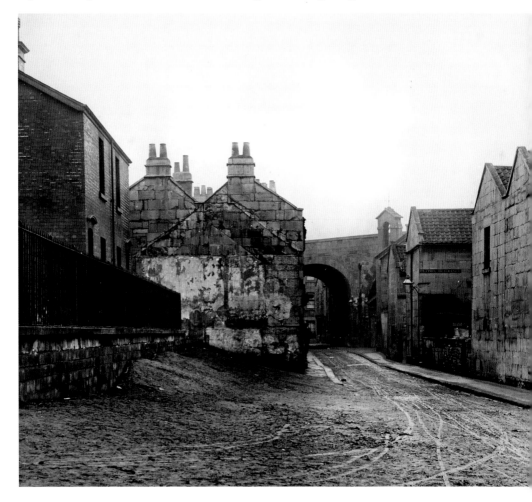

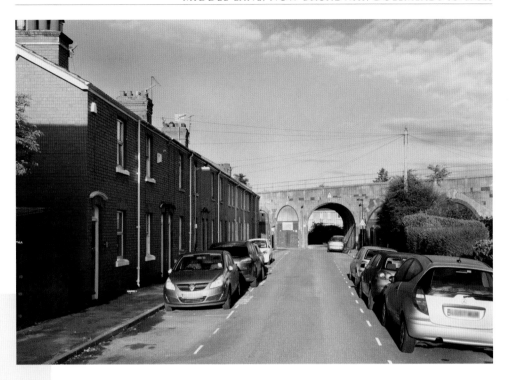

Hence, in the early years of the twentieth century, considerable investment took place to clear the houses built on this low-lying area and replace them with dwellings at a new, raised-ground level 1ft above the highest recorded flood level. The first new properties were ceremonially opened in July 1901.

The two red-brick cottages on the left of the old photograph are shown here in comparative isolation among the remainder of the condemned properties. Yet, gradually, the whole area was raised to the same level and the entirety of the housing replaced over the course of several years. The newly built road lost the old name of 'Middle Lane' and became 'Broadway'. The changed profile of the archway under the GWR viaduct underlines the raised ground level.

On the right-hand side, in front of the viaduct, is the bell-cote of the old Dolemeads Infant School, opened in 1856, and its roofline is still clearly marked on the viaduct wall. A larger, red-brick school was built around the corner in Archway Street to replace this building; its footprint survives as part of the modern Widcombe Junior School playground.

In the nearer foreground on the right are the lost addresses of Plato's Buildings and St George's Place, while the older buildings on the left, awaiting demolition, were Moorfield Place and Poplar Terrace.

The improvements were largely successful and the later, major work on the city's flood defences rendered the area 'dry' once and for all. But the area was not quite safe, as the Dolemeads bore the brunt of some early German bombing in 1941, a year before the devastating Bath Blitz.

# EMPIRE HOTEL, GRAND PARADE, PULTENEY BRIDGE (C. 1870)

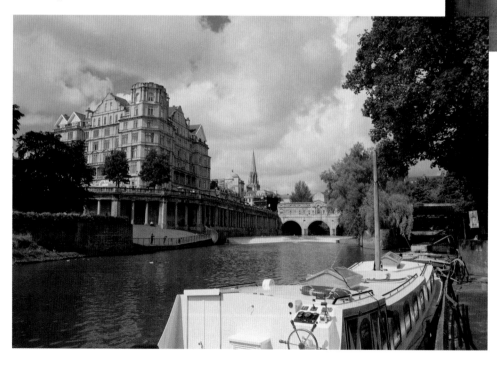

THE VIEW FROM the eastern riverbank near North Parade Bridge is the classic postcard view of Bath. With the eye drawn first to Robert & James Adam's architectural masterpiece, Pulteney Bridge, it is only by degrees that the viewer of the old photograph begins to realise the considerable extent of change in the surrounding scene.

Around the turn of the twentieth century, the area on the left was completely remodelled. The major addition is the Empire Hotel, built in 1899-1901. It was a monolithic exercise in the Jacobethan style, which was popular at the time, and an almost defiant statement by Major C.E. Davis, the then city architect. He was renowned for his work on the development of the Roman Baths / York Street site, but often attracted criticism from those who thought his position as both developer and city architect presented a conflict of interest.

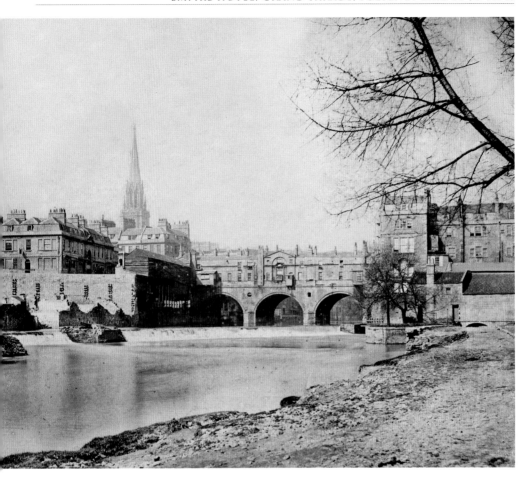

A new road system called Grand Parade was formed around the hotel and led from Bridge Street to Terrace Walk above a colonnade. This had major implications for the area and not only necessitated the removal of the timber vegetable markets (visible on stilts on the western riverbank), but also the demolition of a row of Georgian houses on the eastern side of Orange Grove (their chimneys are just visible, far left) which included the fine Nassau House. A further, later, casualty was the Lower Assembly Rooms known latterly as the Literary & Scientific Institution, which gave its name to the Institution Gardens (now Parade Gardens).

There were formerly mills at either end of the weir. On the eastern riverbank was Bathwick Mill, which predated the whole Georgian development; the top of the archway over its millrace can just be seen. It lay derelict for many years prior to demolition in the 1930s. Monks Mill, on the left, was a traditional fulling mill with an attendant dye works – remnants of Bath's textile industry.

It is arguable that, despite the size and prominent position of the Empire Hotel, it is the Podium development that has had the more disruptive effect on this general view by destroying something of the sense of purpose with which Pulteney Bridge bestrides the river. Having rid the bridge's downstream 'postcard' façade of its chimneys and other encumbrances, it seems rather wanton not to have properly protected its setting.

# PULTENEY BRIDGE (1897)

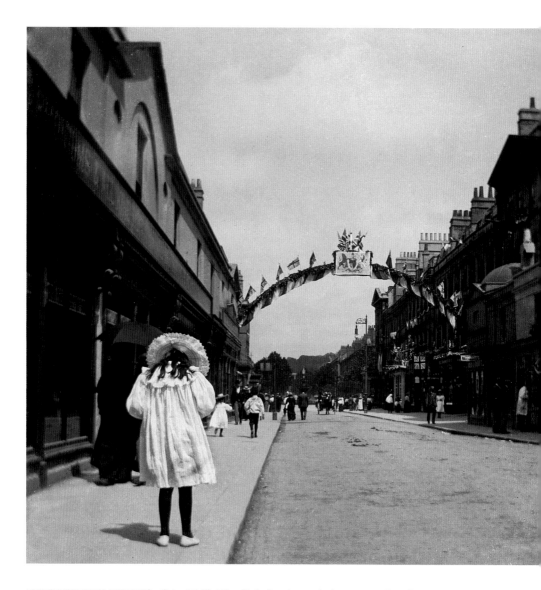

PULTENEY BRIDGE WAS built in 1769-74 to link the city with the new Bathwick estate development on the eastern bank of the Avon. The design still provides one of Bath's greatest spectacles (when viewed from the south!). When built, the ends didn't connect with contiguous buildings, so it was apparent that you were crossing a bridge. These days that effect is lost; if you stand at the bridge's junction with Grand Parade on a summer's morning, you don't have to wait long before you hear the moment it dawns on a group of visitors that they have just crossed the bridge without realising.

One could be forgiven for thinking that the bridge has always been cherished as an iconic structure by important architects and therefore never altered from its original design. In fact, in common with so many of the subjects of photographs in this book, the bridge has seen a lot of change – sometimes involving tinkering at the edges, sometimes something more significant.

It was only twenty years after completion that Thomas Baldwin had his go, adding a storey to the buildings on the bridge. Whether due to the extra weight is not clear, but in around 1800 one of the supporting midstream piers began to give way and had to be rebuilt. John Pinch the elder remodelled the north side before the bridge gradually began to sprout timber appurtenances (and a few extraneous chimneys). These are still in evidence on the north (back) side of the bridge, but were cleared from the southern elevation in 1950.

Perhaps most significant of all were the changes made on the south-western corner in 1903 in order to accommodate the new Grand Parade. This involved moving the domed end pavilion inward by some distance, which destroyed the symmetry of the bridge.

The last changes were effected in 1975 when shopfronts were altered to a uniform design. As well as the charming attire of the girl in the old photograph, the times are marked not only by decorations for Queen Victoria's Diamond Jubilee, but also by the presence on the left of Duck, Son & Pinker. This was the heyday of the purveyor of harmoniums and pianofortes, when people made their own entertainment and when methods of manufacture of musical instruments brought them into an affordable price range. This old Bath firm closed its doors for the last time in 2011.

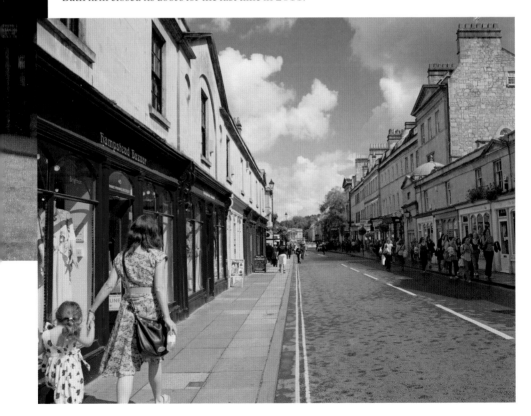

# PULTENEY WEIR
# (1970)

ONE OF THE perennially most photographed scenes in Bath is Pulteney Bridge with Pulteney Weir, the former built around 1770 and the latter built around 200 years later. Formerly a straight, diagonal weir serving a fulling mill at one end and a flourmill at the other, Pulteney Weir was completely remodelled as part of the major works in Bath that began in the late 1960s to try to tame the River Avon.

Since time immemorial, the river was subject to regular flooding, hence the southern city walls were originally built some distance up the slope from the banks of the river. The city's success as a resort in the eighteenth century, in addition to the general gravitation of the population towards cities in the nineteenth century, meant that building was undertaken in the flood plain and buildings higher up added to the run-off into drains. Floods became a regular, if unpredictable, feature of city life.

The areas of Dolemeads and Avon Street were always worst hit, but an area right along the Lower Bristol Road was also affected;

when the Dolemeads were lifted out of the flood plain in the early twentieth century, it should have been clear there would be a knock-on effect.

A flood in 1960 was sufficiently bad to lead Stothert & Pitt to build its new office block on the Lower Bristol Road on stilts, and the Corporation was moved to undertake a huge project, channelling the river right through the city centre into a steel culvert. It is largely ugly and has destroyed Bath's relationship with its waterfront. The work around Pulteney Weir, however, has stood the test of time both visually and as part of the flood-prevention scheme. The worn, old-world feel of the steps up the side of the bridge onto Argyle Street belies the fact that they, too, are a product of the late 1960s redesign of the weir.

In one of the more unwelcoming stretches of the riverside – namely behind the railway station, just below the entrance to the Kennet & Avon Canal – the levels of the major floods are neatly incised on the masonry of the southern abutment of the Widcombe footbridge. It is worth strolling down along the towpath to see them and to reflect on the plight of those in the poorer areas of the city whose lives were thrown into turmoil on each occasion.

# GRAND PARADE / TERRACE WALK (C. 1935)

PRIOR TO THE construction of a bus station between Dorchester Street and Railway Place, Grand Parade served as an interchange for numerous bus services and there is certainly a lot of public transport activity on view in the old photograph, with half a dozen or so buses waiting at stops and a lone tram plying around Orange Grove towards Terrace Walk. This photograph poignantly captures the period when our love affair with motorised transport really took off, sounding the death knell for the trams and, later, significant portions of the railway network. Today the Terrace Walk area, on the left, is again being used as a dedicated drop-off area for visiting coaches and tour buses.

The line of the buildings in Terrace Walk marks the line of the old city wall, inside of which these buildings were originally erected in 1728 by John Wood. A fragment of the city wall, further south but on the same alignment, can be seen in the delivery area of Marks & Spencer, behind Manvers Hall. The major demolition of the city walls took place in the mid-eighteenth century.

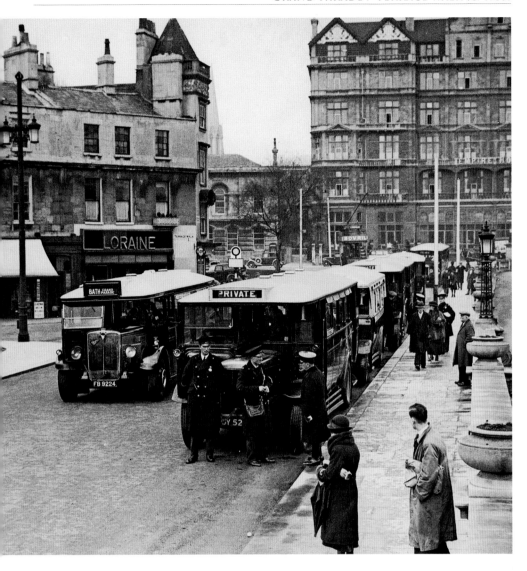

Given the prominence and provenance of the buildings in Terrace Walk, it is a matter of concern that they are not only treated as the backdrop to a makeshift coach park, but that various oddments of window-frame design have been allowed to creep in unchecked over the years.

This area changed significantly in the early twentieth century: houses in Orange Grove were demolished, Grand Parade itself was formed, and the Literary & Scientific Institution (formerly the Lower Assembly Rooms) was removed, with part of its cellar becoming a public convenience that gave rise to the nickname of 'Bog Island'.

Of the shops in the old photograph, Madame Loraine's boutique sold gowns and millinery. Next door were the premises of Wilson Lee & Co., purveyors of sporting equipment. The striped awning belonged to Harrison's cafe, with the Co-operative Insurance Co. offices above. It is perhaps to Harrison's that the Fry's van is delivering.

# HIGH STREET / GUILDHALL FROM THE SOUTH (c. 1890)

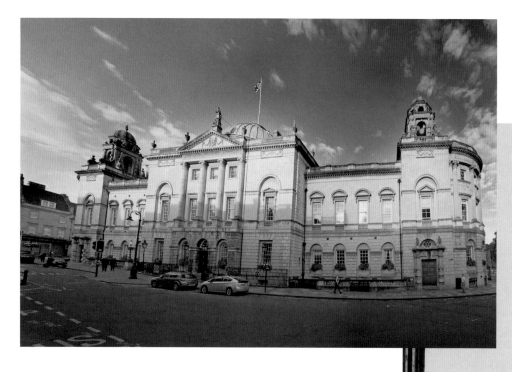

THE 1770S CENTRAL section of the Guildhall replaced earlier structures that were sited on an island in the middle of the High Street, and was designed by Thomas Baldwin when he was only twenty-six years old; it was one of his first projects, but he went on to become City Surveyor and contributed many other buildings to the city, including the main Grand Pump Room, Great Pulteney Street, Bath Street and Somersetshire Buildings in Milsom Street. It is fair to say that, while the Woods steal the Bath limelight, Baldwin's architectural contribution to the city is barely any less significant.

This photograph provides a good view of the screens, which adjoined the Guildhall and contained the entrances to the market halls with their glazed roofs.

Architect John McKean Brydon's north and south extensions (added over 100 years later) represent a hugely successful addition to a prominent building. He went on to provide a similarly successful extension to a Baldwin original at the Grand Pump Room a few years later, followed in turn by the Victoria Art Gallery in Bridge Street as a continuation of his own work.

Here we get a closer view of the southern wing, which has housed municipal offices since it was built. The friezes on the corners provided a thematic link to the aims and aspirations of the city in providing a cultural, educational and organisational framework for citizens and visitors, depicting figures from the sciences and the arts (on the northern Technical School corner), and administrative and local historical contexts (on the southern corner).

Tramlines are clearly visible along the High Street and leading into Cheap Street, but these served horse-drawn trams at this time, as evidenced by the lack of overhead wires. Electric trams were introduced in the city in 1904 and the network was also later extended to include a route through Orange Grove, which at this time was still a pedestrian precinct.

One senses from the old photograph that the Guildhall was a powerful force in the life of the city, presiding over events in the former marketplace and beyond. Today the Guildhall rather has the air of sitting uncomfortably on a giant traffic island.

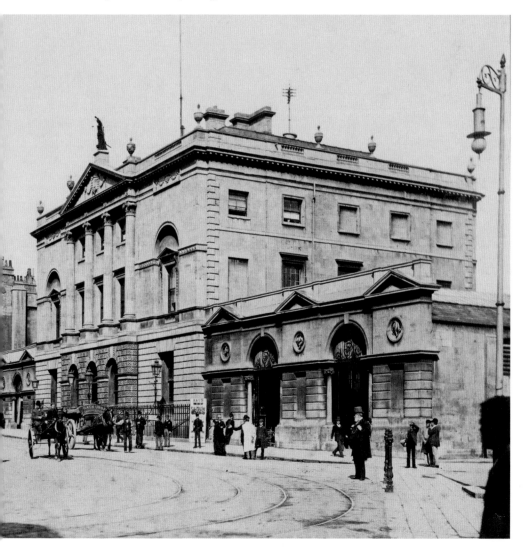

# HIGH STREET /
# BRIDGE STREET (1893)

DOMINATING THIS OLD view of the corner of the High Street with Bridge Street is the White
Lion Hotel, which, along with the Greyhound (on the opposite side of the High Street) and the
White Hart (formerly of Stall Street) was one of Bath's major coaching inns.

Note the ghost-like figures standing on the street corner: the result of people moving during
the long exposure times required for early methods of photography.

Significantly, engineer Isambard Kingdom Brunel was listed as staying at the White Lion
on the night of the census in June 1841, probably checking final details on parts of his Great
Western Railway line prior to its full opening at the end of that month. It was the railway that

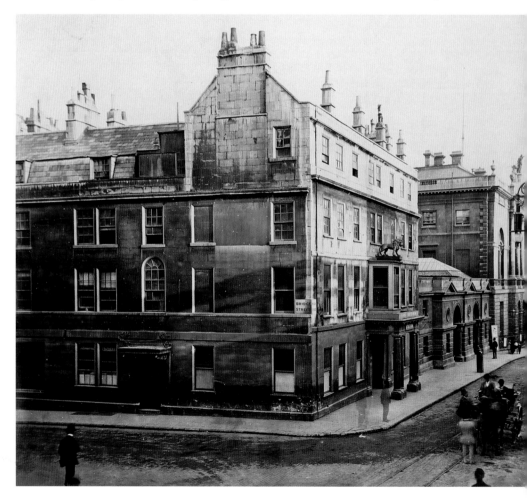

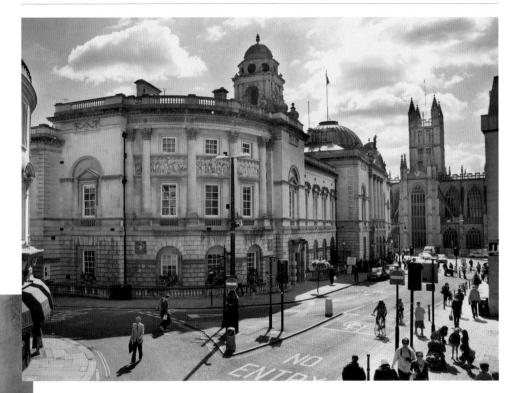

brought on the decline of the coaching inns – although the White Lion was such a fixture in the city, being home to several associations and societies, that it survived until the early 1890s. The White Lion Tap, to the rear of the main premises, was also a popular, if less salubrious, watering hole.

In 1891, plans for a significant extension to the 1770s Guildhall were revealed and the White Lion was demolished to make way for the new Bath Technical School in the northern part of the redevelopment. In the old photograph, scaffolding is just visible at the far end, where Bath builders Hayward & Wooster were in the process of building the southern extension to house additional municipal offices.

Also in evidence here, between the central block of the Guildhall and the White Lion, is one of the screens that gave access through to the markets. These were lost in the redevelopment, replaced in each case with a two-storey section between the Guildhall and its new wings. The central, eighteenth-century building also received its dome as part of these works.

Dwelling on the modern image, it is worth considering that, in recent times, we have agonised over extensions and amendments to significant Georgian buildings in Bath. Here is a fine example of how a prominent building can receive a sympathetic makeover with an architecturally harmonious result. The later addition of the Victoria Art Gallery in Bridge Street continues the theme.

On the extreme right, the splayed corner and ornate shopfront of the old premises of Bath 'conglomerate' Cater, Stoffell & Fortt have now been replaced with the stepped corner of the unpopular 1960s Harvey block.

# NORTHGATE (C. 1930)

THIS BUSTLING SCENE at Northgate is a wonderful snapshot of 1930s Bath, in which the remnants of horse-drawn traffic and an intrepid cyclist intermingle with motorised transport, which was on the rise in terms of both private traffic and delivery vehicles, as evidenced by the lovely Peek Frean's biscuit van, on its way to one of the city's confectioners.

The mix is completed by the rails and overhead wires for the trams, which were by now in their last decade of service in Bath. When in service, trams left the city via Broad Street and returned via Walcot Street. The main ticket office was just out of shot at No. 10 Northgate Street.

The Georgian terrace of Northgate Street was occupied at Nos 7-9 by Horton Brothers, who were furniture sellers, auctioneers and estate agents. Other shops here included Rich & Cooling seed merchants (white frontage) and Arthur Whiting, the cutler. Behind these buildings there were also doorways through to yards with names such as St Michael's Court and Hen & Chicken Court.

After surviving 1930s plans to clear the site for a new road bridge over the river, the Northgate Street properties were ultimately demolished in the 1960s to make way for a multi-storey car park. The wider plans for the river frontage, of which the

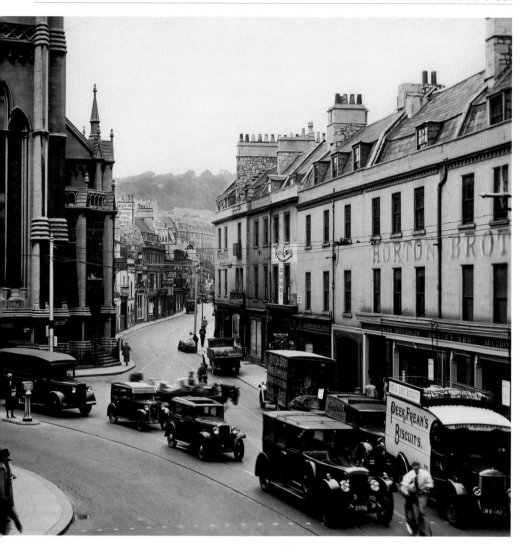

car park was part, were dropped and Bath was left with a raised concrete 'podium' while various later plans for development came and went. The most likely contender for some time was a new set of law courts, but security issues – exemplified by the IRA's 1974 bomb in The Corridor – meant that courts could not be built above a public car park. Bath was thereby spared a modern building that we might by now have come to regret.

In its place, and bearing the name of the concrete podium, we have something of which one can say little more than that it is bland in comparison with its neighbours. The new post office was built in the 1920s, moving from its previous site on George Street. But this vista is made by the elegant presence of St Michael's Church at the junction of Broad Street and Walcot Street. Built in the 1830s to replace an earlier Georgian church, it has an unusual north–south alignment dictated by the site itself. The window groupings are said to have been inspired by the transepts at Salisbury Cathedral.

# WALCOT STREET (1974)

WHEN THE FIRST elements of the long-term Buchanan scheme for Bath began to be implemented, the Beaufort Hotel, as it was initially named, was considered one of the most prominent eyesores, immediately attracting strong criticism and becoming a watchword for all that was worst about the direction of modern development in Bath.

As if the hotel wasn't bad enough, it also had an unsightly neighbour. As part of the underground car park development beneath the hotel, a monolithic concrete structure with the rough proportions of a cigarette packet was considered necessary. Its purpose was variously explained as a 'ventilation shaft' for the car park and something to do with the hotel's lift system. Its position outside a flagship hotel seems bizarre, especially as closer inspection shows that it almost completely blocked the pavement, forcing pedestrians into the road. Only a closer examination of the futuristic Buchanan Plan reveals that this was to be the site of a major feeder road for the dual-carriageway tunnel, which would have disappeared under the Paragon slightly further north. It is therefore possible that the tower was planned to link with some of the raised walkways in this area.

Whether because the Buchanan road scheme was never completed, or because the multi-storey car park was left open to the elements on its eastern side (obviating the need for 'ventilation'), or because of a substantial refit to the hotel, the tower disappeared as recently as 1989, at the same time as the Podium shopping centre was constructed.

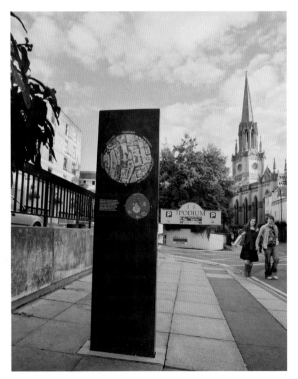

The hotel was bought by the Hilton Group and received a £3 million refurbishment in 1988. Although time has done little to moderate the effect of the hotel, whose rear elevation detracts significantly from the vista of Pulteney Bridge when viewed from Grand Parade or North Parade Bridge, the city seems resigned to it being in our midst for some time to come.

On an approach to Bath that was once lined with historic shops, in the shadow of the rear of the Paragon, the visitor to this area is now greeted with the derelict corn market, the plinth of a demolished public convenience, the side of the Podium, a garish yellow entrance gantry for the Podium car park ... and this hotel!

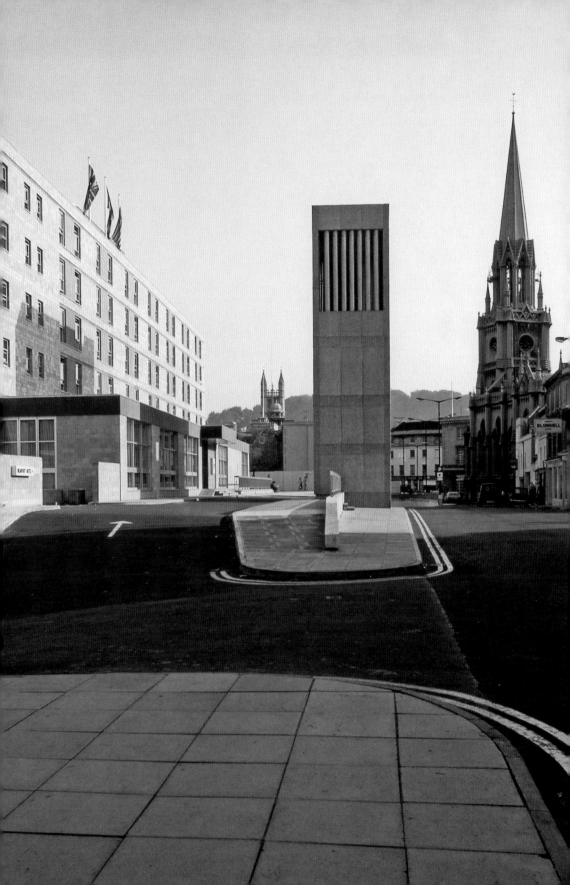

# FOUNTAIN BUILDINGS
## (C. 1920)

FOUNTAIN BUILDINGS STANDS on the spot once occupied by a chapel to St Werburgh and this area has probably been continuously inhabited back into antiquity, given that the area to the north of the walled city has been shown to have been a focus of Roman habitation. The current buildings were erected in 1770.

The corner is dominated in the old photograph by The Cycleries, home of Wallace Motors, purveyors of everything from bicycles to motorcars.

Hay Hill Church was erected on a vacant site in 1868. There had been plans to widen Hay Hill for traffic, but these were not realised and a home was instead built for a congregation from Kensington Chapel that had been using the Assembly Rooms as a stopgap. The architects

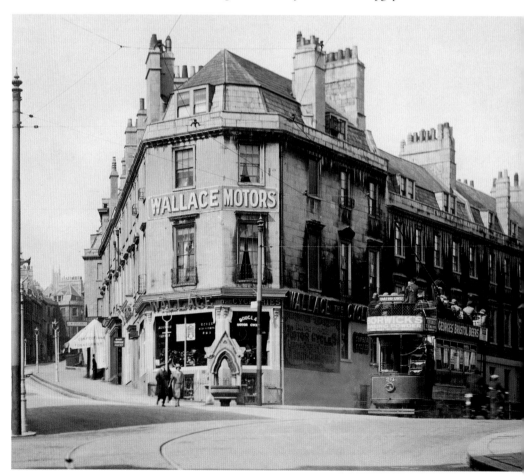

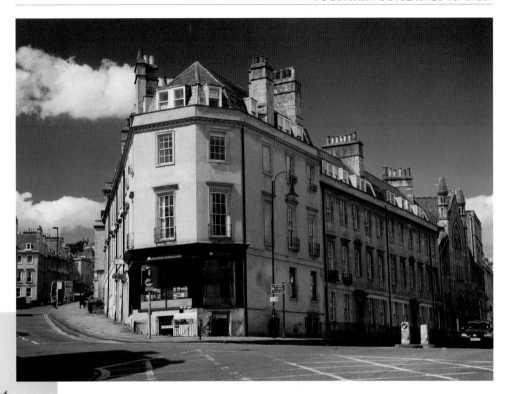

were Wilson & Wilcox and similarities between Hay Hill and their other works
of this time, Manvers Street Baptist Church and Holy Trinity (Chapel Row), are
apparent. A report of the laying of the chapel's memorial stone (just up the stairs
inside the main door) states that it contains a time capsule. Who knows when that
will ever see the light of day again!

At No. 1 Fountain Buildings, next door to Hay Hill Church, were the offices of
Manners & Gill, architects. George Phillips Manners was the city architect and was
responsible for numerous buildings of note around Bath, including many in this
book, such as St Mark's and St Matthew's churches (Widcombe) and St Michael's
(Broad Street).

In front of Wallace's can be seen the public drinking fountain erected in
March 1860 by Bath Licensed Victuallers Association and the Society for the
Prevention of Cruelty to Animals amid great ceremony. A procession from
the Guildhall included the Mayor (Dr Barrett), chiefs of local police, the clergy
and aldermen of the city, and a crowd of 2,000 gathered to witness the official
inauguration. This was the second such public fountain in the city; the first was the
1861 Rebecca Fountain, next to the abbey.

The structure in Fountain Buildings provided water at different levels for horses,
humans and dogs. It is easy to forget how dry and dusty life could be in cities with
unmade roads during dry periods, but the cloud of dust thrown up as a motorcycle
speeds past a tram is evidence of this.

# THE RIDING SCHOOL, MONTPELIER (C. 1890)

THIS IS AN image of Richard Scrase's Montpelier Riding School, built prior to 1770, together with an adjoining shopfront. Around 1850, the stables building on the right was separated from the riding school and, after some internal alterations, became St Mary's Roman Catholic Chapel, a precursor to St Mary's Church which was purpose-built further along the road in 1881. The rooms were then used as a church hall by Christ Church.

The riding school operated until well into the twentieth century, except for an interstitial incarnation as a lecture hall between 1857 and 1870. After James Roberts restored its original purpose in 1871, the building saw a variety of uses between riding lessons. The Somerset Militia

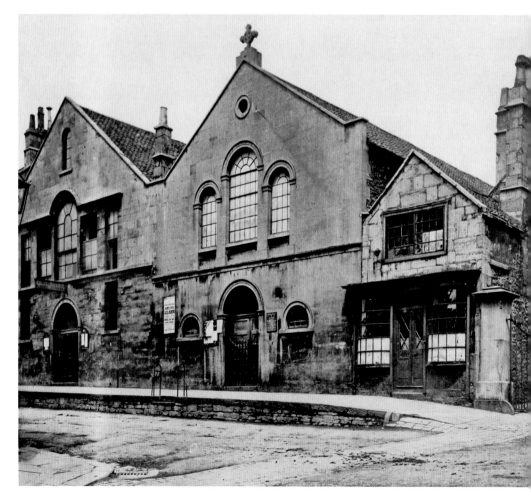

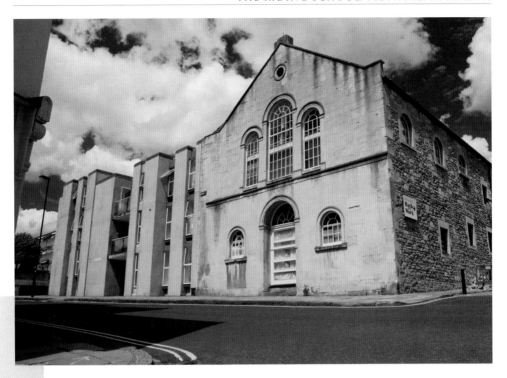

drilled here at such times as they were stationed in Bath (having lost the use of the premises on which St Mary's Roman Catholic Church was built), prior to their settling at the Drill Field and Hall on the Lower Bristol Road. Amongst a number of dog and pigeon shows through the 1880s and 1890s, there is also reference to the Bath rugby team of the time using it for training at the end of the nineteenth century.

On the corner with Morford Street was a solid Georgian townhouse, latterly called Jaguar House, which had served as living quarters to the riding school. When the 'Sack of Bath' was in full swing in the 1960s and this part of town was one of the major clearance sites, Jaguar House and the riding school were allowed to deteriorate to the point of dilapidation and so were demolished. The eighteenth-century real tennis court (roof visible behind these premises) became the focus of a preservation campaign, but its use – and its usefulness – was the subject of extended debate. Eventually, Russell Frears, who had salvaged the contents of Bath manufacturing company J.B. Bowler on Corn Street (when that site disappeared under the new Avon Street car park), saw the opportunity of using the former tennis court building to house a museum of Bath's industrial heritage. This is now the Museum of Bath at Work. The old church hall was transferred to the council for housing purposes as part of the deal.

City architect Roy Worskett identified the corner site as one that should be given over entirely to modern architecture, and the new Jaguar House was vaunted as an example of the type of thing he wanted to see across the city. We are free to form our own opinion as to whether it was a success.

# MOUNT PLEASANT (1965)

ONE OF THE reasons Bath is enshrined as a World Heritage Site is for the development undertaken during the Georgian era. While the contribution of the Victorians to the cityscape is less well known, they also made positive additions to the city, including some sensitive infill and wonderful church architecture, usually involving high standards of workmanship. Even the early years of the twentieth century saw a new interpretation of classicism, with touches of contemporary design, whose scale and style was not out of place in the historic setting.

What happened after the Second World War, however, is well known as the period when it all went badly wrong. Swathes of eighteenth-century buildings were cleared wholesale, with justifications ranging from their uninhabitable condition, the need to provide new housing developments with room for car parking, and the imperative of making way for planned road schemes. The scale of the clearances, the quality of some of the buildings that were being lost and the lack of regard for the coherence of the city's architectural core led to it being labelled the 'Sack of Bath' by *The Times* feature writer Adam Fergusson, who brought the plight to national attention and put his case in a book of this name – and the momentum of the 'Sack' was stopped. Sir John Betjeman had publicly supported the campaign and contributed the foreword to Fergusson's book. Lord Snowdon visited Bath and highlighted the extent of the destruction with his camera.

But the Sack was not stopped in time to save this area below Lansdown Road. Ballance Street and Lampards Buildings were flattened (along with most of Morford Street) and replaced with some of the worst examples of post-war architecture that were inflicted on Bath. Mount Pleasant formerly ran down from Lansdown Road to the end of Portland Place. The large townhouses in the centre of the old photograph were Belvedere Place and No. 18 Lansdown Road. The lower section of the front wall of No. 18 still remains. On the far right is the house at the top of Lampards Buildings, and the cream-coloured façade on the left is the shop run by Raimondo Butera.

In the modern photograph, the stone newel at the end of the same sloping pathway provides a bizarre reference point, but the wider view is rendered impossible as one monolithic part of the Ballance Street development was built straight across the middle foreground of the old shot. Its disregard for its surroundings – even for the contour of the site – has led to it being considered among the worst excesses of the period.

# ST ANDREW'S CHURCH, JULIAN ROAD (1930s)

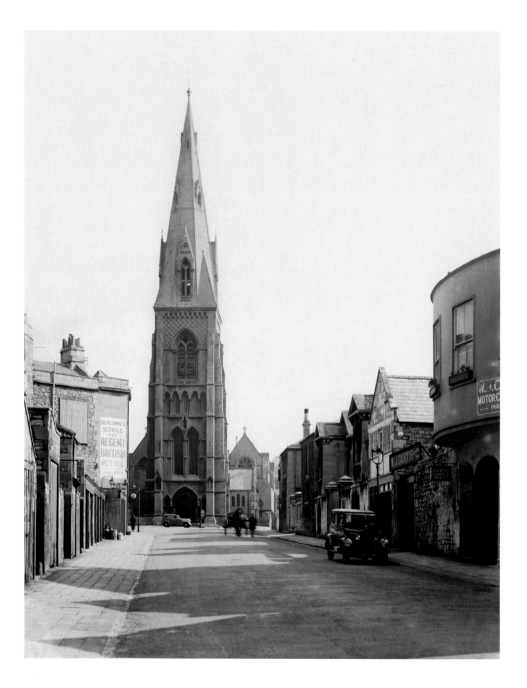

THE UNASSUMING TRIANGULAR patch of grass behind the Royal Crescent hides a long history, which includes Roman burials and the junction of major Roman roads.

A large residence called Harley House once stood here, but made way when Walcot parish required a chapel-of-ease to serve this auspicious, growing neighbourhood and specifically to relieve St Margaret's Chapel in Brock Street. St Andrew's was thus conceived for a site which had long been earmarked for a church; (Upper) Church Street was so named around 100 years earlier. Of its dedication it is said that the link to Wells Cathedral was taken into consideration, as was the simple fact that this was the remaining 'major' saint without a church to his name in the city.

The architect was Sir George Gilbert Scott (most famous for the Midland Grand Hotel at St Pancras Station), with the work largely undertaken under the jurisdiction of his son John. The church opened in 1873, still short of its spire and organ. When completed in 1879, the result was the tallest building in Bath (just a couple of feet taller than St John the Evangelist) and drew fulsome praise for the craftsmanship and selection of materials employed in building a church that was very much in tune with architectural tastes of the time. John Wood the younger, however, may have had something to say about the effect of the massive spire on views of the Royal Crescent.

The church lasted just over sixty years before it was a casualty of the German bombs on the first night of the air raids in April 1942. The damage ultimately necessitated the complete demolition of the church. The destruction of the church was mirrored by personal tragedies. The former Mayoress, Mrs Langworthy, was killed in the raids and had been due to be married at St Andrew's the following Wednesday. The new rector of Walcot, Revd Woodmansey, had been inducted into the parish just days previously and, when St Andrew's was bombed, bemoaned the fact that he had not yet had the pleasure of taking service there. The next night he was killed as he stood outside the Regina Hotel in Bennett Street when it took a direct hit.

When the replacement St Andrew's Church was built, later, on the former Huntingdon Chapel burial ground across the road, the vacated site had to be left as compensatory open space.

# MILSOM STREET (1897)

QUEEN VICTORIA WAS the first monarch to reach the milestone of sixty years on the throne and Milsom Street is seen here bedecked in celebration of her Diamond Jubilee. From the *Bath Chronicle & Weekly Gazette* of 13 May 1897:

> *The Milsom Street Committee has formulated its scheme, and a very elaborate one too. Alternate festoons of evergreens and fairy lamps will be suspended at intervals across the street. An ornamental fountain is to be placed at the top of the street upon which, at night, lime-light men will direct coloured lights from points of vantage at the two banks on either side of the street. On the blank wall facing Milsom Street at the bottom, a brilliant electric display will be arranged, and to add to the effectiveness of the scene each shopkeeper will doubtless do something in the way of individual decoration. The residents in Edgar Buildings are also discussing a scheme for a great electrical display right along the buildings, which, if carried out, as we hope it may be, will give an admirable finish to the Milsom Street illuminations. The decorations and illuminations ... in this neighbourhood at least, bid fair to totally eclipse the 1887 celebration. It only remains for the tradesmen in all other principal thoroughfares to emulate the example thus set.*

The photographer has captured the pose of a young man, clearly very proud of the fine way he is turned out. Although it looks as though everyone in the picture is in Sunday best, the girl in white on the far left appears to be exiting Merrikin & Sutton's chemists (now Mimi

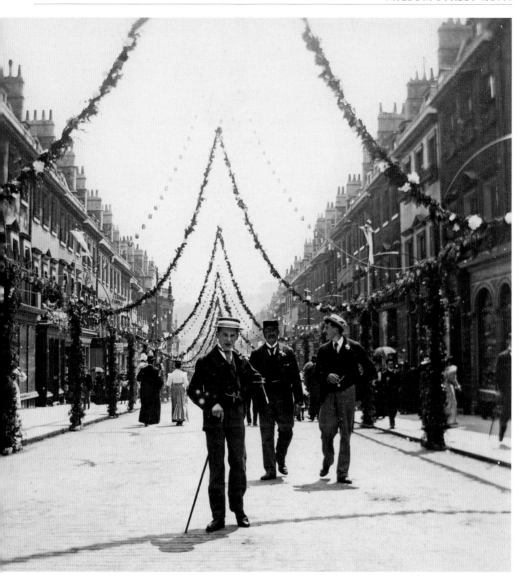

Noor), so perhaps the shops were open. Also just legible on the left is the fascia of Parkhouse Oriental Goods Depot (now Cargo).

Milsom Street is still the hub of Bath's shopping experience, but was originally conceived as a parade of uniform lodging houses, each with a railed basement area. The uniformity was first disrupted by the addition of Somersetshire Buildings, the set piece on the eastern side, which was built on the site of a poor house; the gradual conversion of properties to shops completed the erosion. Today Milsom Street suffers from botched pavements, unfitting street furniture, parked cars and loitering buses.

Having just marked the second Diamond Jubilee in 2012, it seems clear that we cannot hold a fairy lamp to the efforts of the Victorians when it comes to celebratory street decorations!

# QUEEN SQUARE (C. 1950)

DURING THE SECOND World War, Queen Square lost its iron railings and a considerable portion of the buildings on its southern side. The railings went as scrap to the war effort and the eastern end of the Francis Hotel took a direct hit in the German air raids of April 1942.

The old photograph is clearly taken after the clear up has taken place and the end wall of the remaining part of the Francis is shored up with timber. The missing section of the hotel opens up a view of the buildings that existed around a yard accessed from Barton Street; these have since been replaced by a modern annexe and the hotel's car park.

The bronze plaque, standing beneath the tree in the south-eastern corner of the garden, contains an inscription that replicates the wording of the original dedication on the central obelisk.

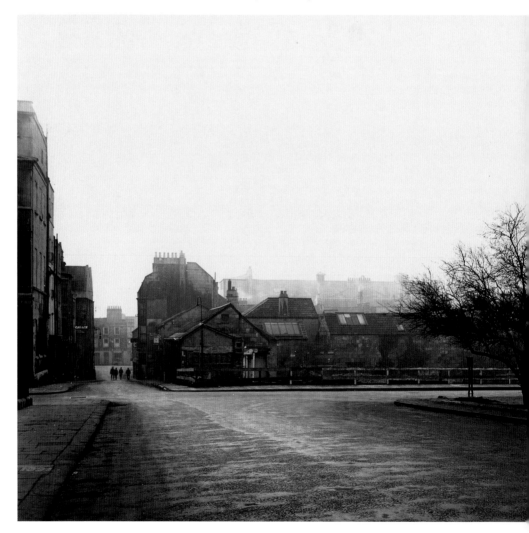

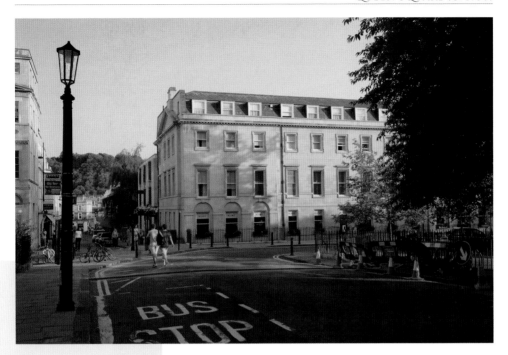

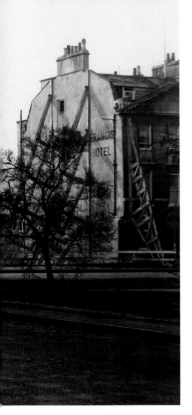

This commemorates the visit of the Prince of Wales (Prince Frederick) in 1738 and was erected by Beau Nash.

The erection of bronze plaques around the city was first suggested in 1898 by T. Sturge Cotterell, a former mayor and alderman of Bath and keen local historian. Originally forty-five were erected to different personages, but this number has increased over the years and there are now around sixty.

It appears that there was a path from the south-eastern corner into the centre of the garden at this time; originally the entrances were in the middle of each side and the garden was surrounded by a low balustrade wall. Today the garden can only be accessed from the middle of the southern side and the visitor must run the gauntlet of crossing one of Bath's busiest roads to reach it. The Cotterell plaque is still in place, but as there is no entrance at this corner, its position seems a little absurd.

There is a certain regularity with which various suggestions are made on how to rid Queen Square of the blight of traffic, but short of revisiting the Buchanan Plan from the 1960s, which suggested tunnels from Walcot Street through to Charlotte Street, it is hard to see how this will ever happen.

The Francis, meanwhile, has recently reopened after a major refit and remains one of the best addresses for visitors to the city.

# ST ANN'S PLACE (1972)

BUILT AS PART of the 1760s development that also saw New King Street spread west from Charles Street, St Ann's Place is redolent of courtyards that were once numerous among, between and behind Bath's more presentable façades. Most disappeared during successive phases of development around the city, as they were often claustrophobic and home to very low-grade accommodation with little access to light and fresh air.

St Ann's Place itself was nearly lost in the 'Sack of Bath'. In contrast with much of Bath's Georgian 'artisan' housing, it survived. Today we wonder at the scale of the drive to replace old with new in the 1960s and 1970s, but there were strong forces at work. The fashions of the time not only had people clamouring for the clean lines of newly built houses with their flush doors, simple architraves and uncluttered interiors, but those who lived in older properties often tried to modernise them in the same way, tearing out period plasterwork and woodwork in an effort to join the modern age.

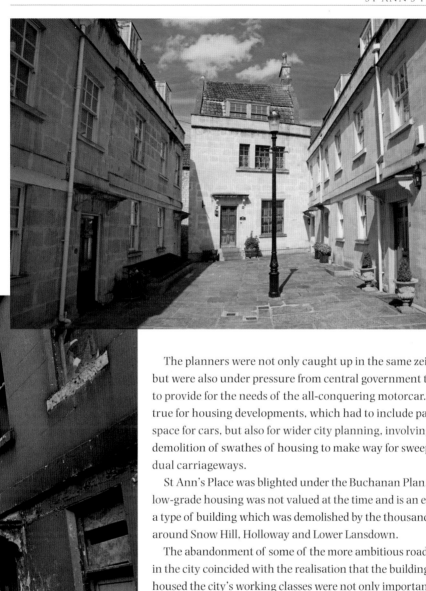

The planners were not only caught up in the same zeitgeist, but were also under pressure from central government to do more to provide for the needs of the all-conquering motorcar. This was true for housing developments, which had to include parking space for cars, but also for wider city planning, involving the demolition of swathes of housing to make way for sweeping urban dual carriageways.

St Ann's Place was blighted under the Buchanan Plan. Its low-grade housing was not valued at the time and is an example of a type of building which was demolished by the thousand in streets around Snow Hill, Holloway and Lower Lansdown.

The abandonment of some of the more ambitious road schemes in the city coincided with the realisation that the buildings that housed the city's working classes were not only important parts of its heritage, but could also be restored and made habitable.

Seeing just how dilapidated the cottages became prior to their restoration, the modern photograph leaves one reflecting how much more characterful the fringes of the city centre could be if they had received the same treatment.

The removal of the lean-to construction on the front of the house at the far end has now opened up a view of the rear of houses in Monmouth Street (part of the main thoroughfare to Bristol), showing that these are considerably older than their eighteenth-century frontages.

67

# GREEN PARK STATION (C. 1947)

GREEN PARK STATION was opened in 1870 as the terminus for a branch line of the Midland Railway, which ran between Birmingham and Bristol, with the Bath branch joining the main line at Mangotsfield. From 1874 the station also carried services on the Somerset & Dorset Joint Railway, which meant that passengers could connect on north–south services. From 1927 until 1962, there was a famous once-daily Manchester–Bournemouth service called the Pines Express which called at Bath before puffing up around the edge of Oldfield Park and into the Devonshire tunnel, or steaming out towards Bristol on its afternoon journey home.

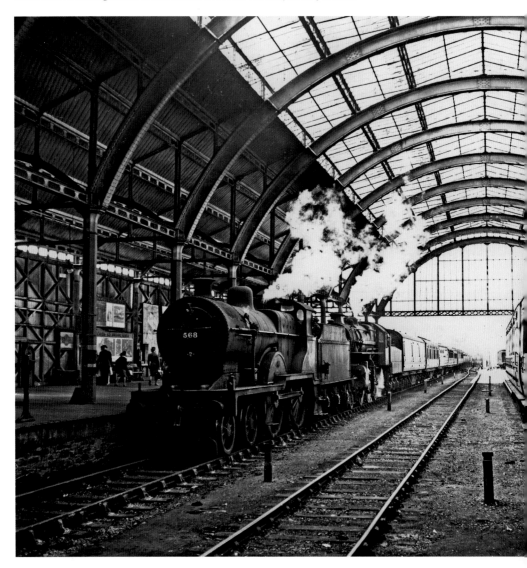

Eventually, the famous 'Beeching cuts' of the 1960s set the points for a generation of travel planning skewed in favour of investment in road networks, and in 1966 Green Park saw its last scheduled train service before closing for good as a railway station.

There followed a period in which the future of the station was far from clear. Originally it was scheduled for demolition due to the Buchanan Plan earmarking the site for a major arterial road, which never materialised. The station became increasingly rundown to the point of dereliction during the 1970s, although its listing status was upgraded from Grade III to II in 1971. The Bath Corporation purchased the building in 1974, but still with its internal reports recommending demolition rather than restoration.

Numerous uses were proposed, including a bus and coach terminus, or parking for a hotel, which would have been built on the goods yard outside the main station train shed. At last, in 1977, the site was bought by Sainsbury's, which was looking to expand out of its small Southgate Street supermarket and build the city's first superstore. With the cost of renovating the station structure falling to Sainsbury's as part of the package, the station was saved.

Now operated by the Ethical Property Co., the station and the train shed is used for a hugely popular weekly farmers' market, as well as for concerts, art fairs and other less formal leisure activities, with the main station building home to a brasserie and meeting rooms.

Most of the original Bath–Mangotsfield branch line is now an excellent cycle / leisure path; the Avon Valley Steam Railway, based in Bitton, also operates along about 3 miles of the track.

# VICTORIA BRIDGE ROAD
## (C. 1940)

THIS VIEW DOWN Victoria Bridge Road shows an area that is currently undergoing significant change. At the time of the old photograph, the entire area in the foreground, including the houses in Victoria Terrace (pictured) and the further side streets of Percy Terrace and Longmead Street, belonged to the Bath-based engineering company Stothert & Pitt.

Founded in the 1780s, Stothert & Pitt supplied ironwork and machinery, most notably cranes, around the world. For generations, significant numbers of Bath men were apprenticed and trained in the manufacture of world-class products, with work focused in the Victoria Works (seen here on the right) and the Newark Works on Lower Bristol Road. As with many large firms, the company also provided a focus for social and sporting endeavours and there was even a company magazine to record major contracts, new products and personal presentations on the occasions of weddings, retirements, etc. Just to the right of the point from which the photographs are taken was the Stothert & Pitt canteen, now the site of Sainsbury's petrol station.

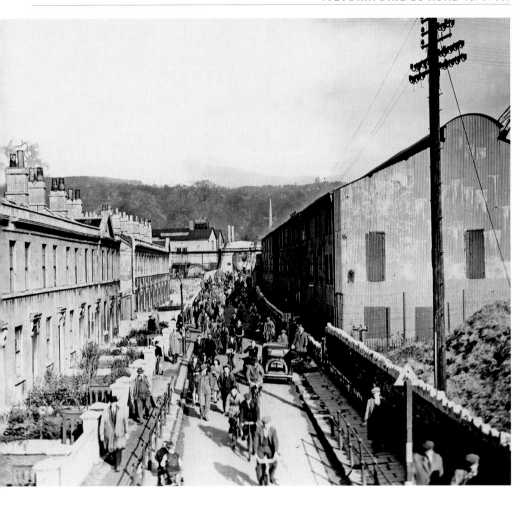

In 1986, the company was bought out by the Robert Maxwell-owned Hollis Group. The situation was short-lived as Maxwell's empire collapsed after his death and the subsequent discovery of huge holes in the group's finances. An attempted management buy-out was unsuccessful and Stothert & Pitt ceased trading in all but name in 1989, ending an important era in Bath's employment landscape.

In the old photograph, a crowd is coming over Victoria Bridge. The bridge was the first of its type, designed and built in 1836 by a brewer called Dredge whose premises were nearby in the Upper Bristol Road. The novel principle of the bridge lies in the fact that its deck is not hung from two main cables; a number of chains are instead cantilevered over the piers and each supports a specific point on the deck, hence the number of chains diminishes towards the centre. Dredge sold his successful design for use in a number of sites, but only three now remain. Whereas the Dredge Bridge of Oich, Scotland, has recently been the subject of a significant and worthy restoration, the original in Bath has been allowed to decay at the hands of the local council.

The new Bath Riverside development is replacing housing where the Stothert & Pitt terraces were demolished in the 1940s.

# ST JAMES' CEMETERY
## (C. 1870)

THE CEMETERY ON the Lower Bristol Road was created to serve the parishes of
St James (city centre) and Lyncombe & Widcombe. It was consecrated by Lord
Auckland, Bishop of Bath and Wells, in January 1862. The chapels were by city
architect Major Charles Davis.

The considerable cleft between conformist (Church of England) and nonconformist
(Baptist, Methodist, etc.) churches in those days necessitated the building of separate
chapels. While these differences are not as significant today, advertisements for
domestic staff in the 1860s could specifically exclude 'dissenters' and there was little
in the way of 'communion' between the confessions.

As such, the chapel on the left was for nonconformists and its exact twin
on the right for Church of England. Half of the foundations of the bell turret
were sited on consecrated ground, to allow the bell to be used by both sides
of the confessional divide. Originally, five acres of the eight-acre site were
consecrated but, by 1869, the proportion of the first 2,300 burials to take place
was so heavily skewed towards members of the Church that more ground was
consecrated in response.

The grounds were planted up by Daniel Butler of Widcombe and the whole formed such a picturesque scene that when the Duke and Duchess of Connaught were presented with a book of forty Frith photographs of Bath during their 1881 visit to the city, the cemetery was the subject of one of the plates.

Haycombe Cemetery, on the south-western edge of the city, was opened in 1937 and St James' Cemetery was closed along with others across the city. Since then, St James' Cemetery has suffered gradual decline despite the best efforts of the council maintenance teams.

The Lower Bristol Road frontage, including an attractive gatehouse and walls, had its ironwork removed as part of the war effort, and views into the cemetery are now obscured by trees and bushes. In 1978 the slender spire on the bell turret was considered unsafe and taken down. It is still stored inside the chapels in numbered pieces and could, with sufficient funding, be restored. Some headstones and monuments have been dismantled in line with recent health and safety initiatives. The tracery in the chapel windows is obscured by sheets of protective perspex.

Also of interest in the old photograph is the absolutely treeless appearance, in the far distance, of what later became Alexandra Park.

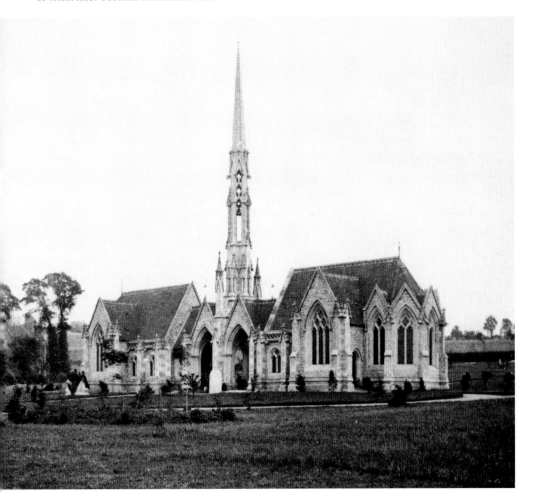

# ASCENSION CHURCH HALL, MAYBRICK ROAD (1910)

THE CENTRE OF the city of Bath is much photographed and, as this book demonstrates, many photographs exist of long-forgotten corners and details of the cityscape, making it possible to piece together the chronology and history of the built environment. In addition to the many tourists and photo-postcard companies who used images of the city, Bath had at least its fair share of early amateur photography enthusiasts and the photographic record is therefore relatively extensive. Out in the suburbs, however, buildings can easily pass undocumented into obscurity, despite having played a significant role in community life. One such building is the Ascension Hall or Church Rooms in Maybrick Road, shown here.

The Ascension Church in Claude Avenue was dedicated on Ascension Day 1907 and opened to serve the growing housing development of South Twerton, as it was then known. At first it

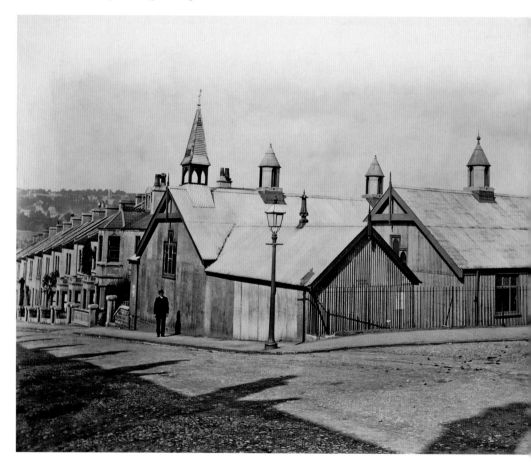

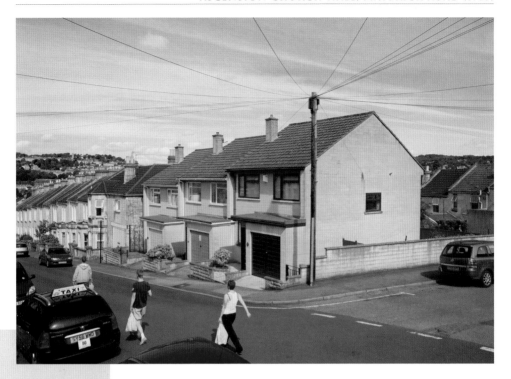

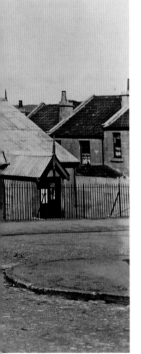

was a satellite church of St Michael, Twerton. The site was in the Twerton parish, but hard up against the boundary with Lyncombe & Widcombe. It became the head church of a parish in its own right in 1912.

The pictured 'tin' building in Maybrick Road predated the main church by about ten years, so may have been a previous incarnation of the church, but for the majority of its existence it served as the church hall. It was not only home to church events, but also pantomimes, whist drives, public meetings, Labour Party bazaars and also wedding receptions for members of the community.

Despite work in the early 1960s, the hall was not properly weatherproof, so the decision was made in 1964 to sell the site for its value as building land in order to raise the funds needed to erect a new, prefabricated hall on the main church site, which finally went up in 1969. The parishioners undertook the building work on the new hall themselves in order to save money. Oldfield Park Methodist Church had a hall of similar construction until recently, but it was demolished when the church was converted to flats.

The moral of the story is that the further one moves from the city centre, the greater the importance of private photograph collections in preserving a visual record of the city's history. Never throw old photographs away, especially if rare old corners of Bath are shown! Old pictures of weddings, dances, rambles, etc. can be an extremely valuable resource for the historians of the future.

# WESTGATE BUILDINGS
# (1932)

THE APPARENT SIMILARITY between these photographs is credit to L.G. Ekins, architect of the Co-operative Society in the 1930s. Having bought up the various properties at Nos 5-9, seen in the old photograph with their mixture of shop and dwelling frontages, the Bath Co-operative Society made this its headquarters, moving from a site in Oldfield Park on the corner of Moorland Road and Shaftesbury Road (now a convenience store). They embarked on creating a state-of-the-art department store, which was to be a fixture in the Bath shopping scene for around sixty years. This necessitated the complete demolition and rebuilding of the site.

With a design that attracted positive comments from the Old Bath Preservation Society (a precursor of the Bath Preservation Trust) at the time, Ekins designed a façade that retained

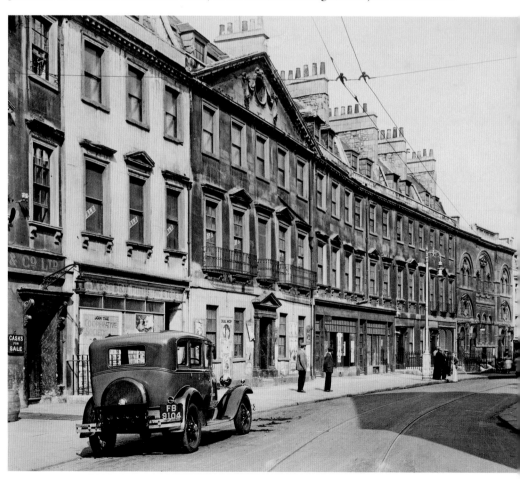

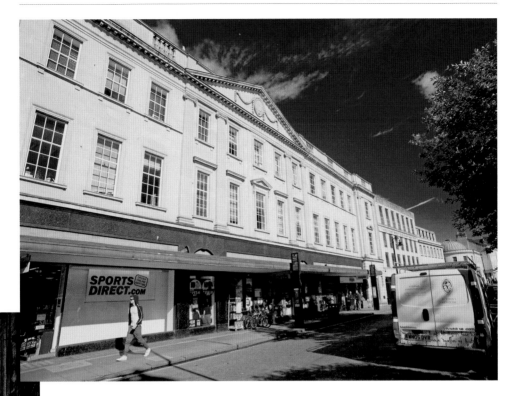

the scale and style of the previous buildings, but incorporated a grand recessed entrance and a ground-floor arcade.

While it is tempting to think of the Georgian centre of the city having remained intact prior to the 1942 air raids and the 1960s 'Sack of Bath', in fact the 1930s saw a considerable amount of redevelopment and change around the city, with major works of the time including the removal of the Literary & Scientific Institution from Terrace Walk, the rebuilding of parts of the High Street, Stall Street and Southgate Street, plus the addition of the Forum cinema and what became Churchill House. Through an adherence to an appropriate scale and use of local stone, while relying on a contemporary interpretation of neoclassical design, it is probably fair to say that history does not judge these well-crafted 1930s additions harshly.

Already completed in this photograph is the replacement far end of the terrace, known as 'Bush Corner', named after the extensive grocery business of Sydney Bush, which operated there until the 1960s. Compare this with the less fortunate contribution of 1960s / 1970s – and later – architecture in the city and it is perhaps a good thing that the Co-op's 1978 plans to demolish its Westgate Buildings store in favour of a new hotel complex were rejected, although Rosenberg House across the street, which was built as part of the St John's Hospital complex around that time, is by no means an eyesore.

The extreme right-hand edge of the old photograph is formed by Chandos House, once a courtroom that featured an underground tunnel to the dungeon which existed in cellars below what is now the Cork public house.

# KINGSMEAD SQUARE
## (C. 1903)

THIS SCENE IS dominated by the presence of Rosewell House, formerly known as 'Londonderry'. It was the work of Bristol architect John Strahan, a rival of John Wood the elder at the time. Strahan also designed other buildings in this area of the city, including Beauford Square. Rosewell House was built in a baroque style for Thomas Rosewell of Bristol and the cartouche beneath the pediment contains his rebus, combining a rose and a well.

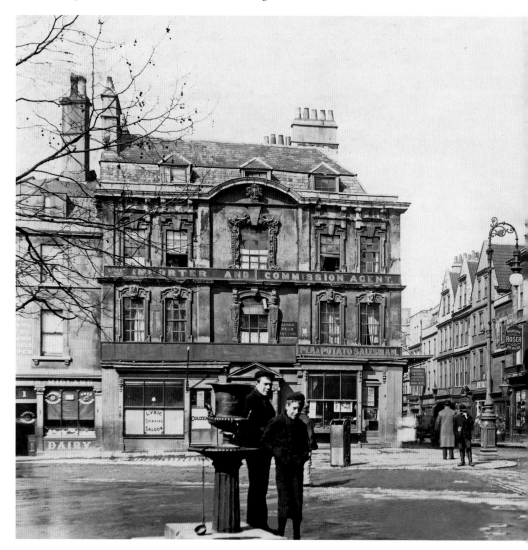

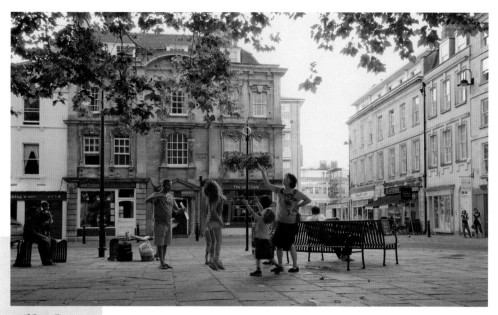

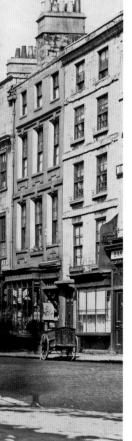

The old photograph shows a number of people who stood still long enough to be captured on film, but there is also a blur and two ghostly feet towards the right of the picture, where someone hurried through.

Kingsmead Street, to the right of Rosewell House, was once a bustling thoroughfare out of the city but was the scene of considerable destruction in the 1942 air raids and its route has now been cut off by the post-war erection of Rosewell Court flats (a well-meaning choice of name but really no match, architecturally, for its namesake) and the telephone exchange. Trams and buses used to trundle in and out of town along Kingsmead Street and it was the erection of a bus shelter in 1941 that ultimately displaced the drinking fountain, which had stood here on a stepped plinth with its cup and chain since the 1860s when it was given by an anonymous donor.

Kingsmead Square used to mark the beginning of where more salubrious Bath gave way to the notoriously poor and sometimes squalid areas surrounding Avon Street and Milk Street, with some of the pubs around the square and nearby Westgate Place enjoying less-than-perfect reputations. The drinking fountain would have been of service to those who would otherwise not have had access to clean water. Although a water main was laid through the area, many houses were slow to connect to it.

Today Kingsmead Square is a vibrant place with people coming and going on their way into and out of the city centre, and others who tarry to enjoy some of Bath's still-too-rare pavement dining at the cafés and coffee shops on its corners, or who just sit and watch the world go by from the comfort of the unusual street furniture. Its massive plane tree – grown so much in the last 100-odd years – also contributes to the feel of the square.

# SAWCLOSE (C. 1930)

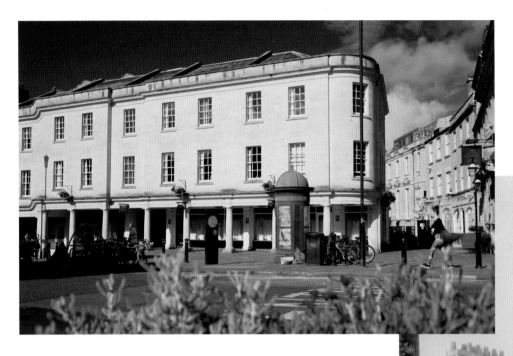

THE OLD VIEW here is of New Westgate Buildings, with a glimpse down St John's Place as far as St Paul's Hall. The hall once belonged to Holy Trinity Church at the corner of Monmouth Place and Chapel Row and now operates as the children's theatre, The Egg.

St John's Place, when built, emulated Trim Bridge in taking the Georgian development beyond the medieval city wall onto land owned by St John's Hospital, still major landowners in the centre of the city today.

New Westgate Buildings, in the foreground, was demolished in the late 1930s to make way for a widening of the street into Sawclose from Westgate Place. The Peep o' Day public house was named after the play last shown at the nearby Theatre Royal prior to it suffering an extensive fire on Good Friday 1862. The pub itself closed in 1910, but when Joseph Lee took it on and turned it into a fish bar the building enjoyed a new lease of life. It is interesting to note that the advertising on the building proclaims its offering of 'Fish & Oysters', yet it is more coy about other products sold. In 1940, an article in the *Chronicle* featured Mr Lee lamenting the decline of the snail trade, due, in his mind, to local gatherers of snails – whom Mr Lee had formerly paid between 6*d* and 1*s* a peck – having exhausted the supply. He himself said he preferred them to oysters or steak.

It seems that No. 4 New Westgate Buildings disappeared somewhat earlier than the remainder of the row, enjoying a short existence as what appears to be a public convenience.

The modern 'Seven Dials' complex (1990), which ultimately replaced New Westgate Buildings, put an end to more than half-a-century of previous failed developments and indecision on this site. Having referenced other Bath architecture – notably how to step a terrace down a hill *à la* Pinch's Raby Place – the development has fitted in well and now serves as a backdrop to further indecision over what will become of Sawclose as it strives to escape its ongoing existence as a municipal car park.

As well as recalling the days when St Paul's Hall was home to the Gemini (later Robins) cinema, many will remember the intervening incarnations of the triangular plot below, which was a car park before becoming home to Tiffany's / Chemies nightclub with Pointing's Garden Centre on the roof.

# TRIM BRIDGE AND
# ST JOHN'S GATE (C. 1905)

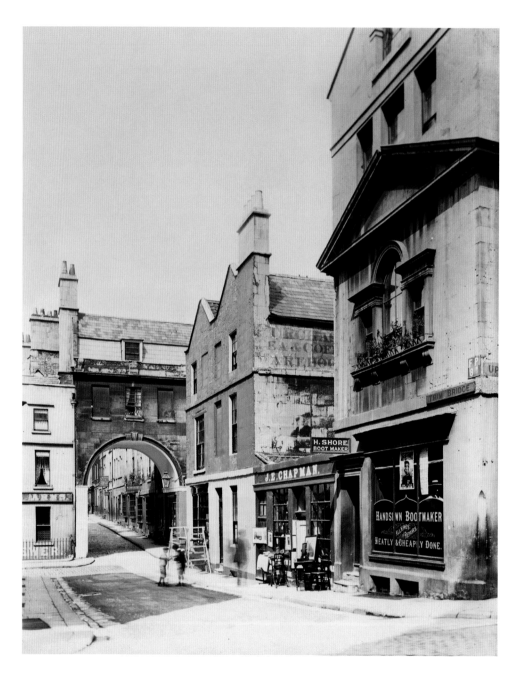

TRIM BRIDGE AND Trim Street represent the first major Georgian building development outside of the medieval city walls, and construction began in the first decade of the eighteenth century. The rebuilt section of city wall in nearby Upper Borough Walls makes it easy to visualise how Trim Bridge crosses what would have been the old ditch, sloping down to the ground beyond the wall. This land was owned by clothier George Trim, a member of the Bath Corporation at the time. But Trim Street was by no means the first extension of Bath beyond the walled city; other areas to the north – certainly Walcot Street and Broad Street, up to Fountain Buildings – have been inhabited since antiquity. St John's Gate was built as an access way towards the new, fashionable area of Queen Square, which was built twenty years later.

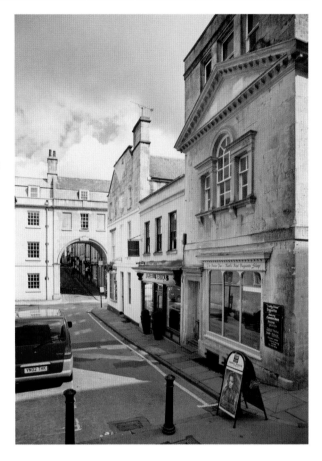

There is a pleasing continuity between the two photographs, even though changes have taken place in an area that one might consider the heart of Georgian Bath, albeit not part of the showpiece cityscape. Parish boundary markings are carved above the stringcourse of the corner house on the right. 'S.M.P' denotes St Michael's Parish, centred on the church in Broad Street, and 'S.P.P.P' is for the abbey parish of St Peter and St Paul. On the far left of the old photograph is the Cabinet Maker's Arms public house, which was in existence at No. 4 Trim Street from around 1837-1920.

The shop with the (now pink) bow window on the corner of Trim Street was once the shared offices of Messrs William Smith and Jeremiah Cruse. At the turn of the nineteenth century, Smith, known as the 'Father of English Geology', was developing his theory of the order of geological strata with a view to helping prospectors locate valuable resources, and was preparing a significant publication on the subject when he came to be in demand around the country for his more prosaic skills as a land-drainer. He set up his office in Trim Street with the surveyor Jeremiah Cruse, also displaying his growing fossil collection here to help demonstrate his stratigraphic theorems.

The main architectural modifications to be seen are the addition of a storey at No. 3 Trim Bridge and the loss of one on the corner at No. 18 Upper Borough Walls.

# TRIM STREET (1950s)

THIS IS A view along Trim Street from a perpendicular angle to the previous photograph showing Trim Bridge (pp. 82-3). Whereas that view showed a high degree of continuity, this demonstrates how the north side of Trim Street between Barton Street and Queen Street was replaced in the 1960s.

No. 1 Trim Street was built in 1710 and is thus among the very earliest of the developments outside the city walls. It was home to printer / lithographer Ernest Adams, with the continuation of the northern side of the street housing the cardboard-box manufacturer J.J. Lee & Sons. Having moved into premises on the south side of the street in 1875, Lee's moved across the street and gradually bought up a large portion of the block between Trim Street and Harrington Place,

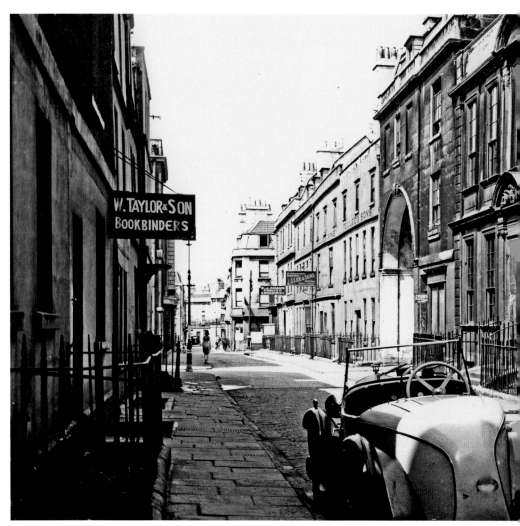

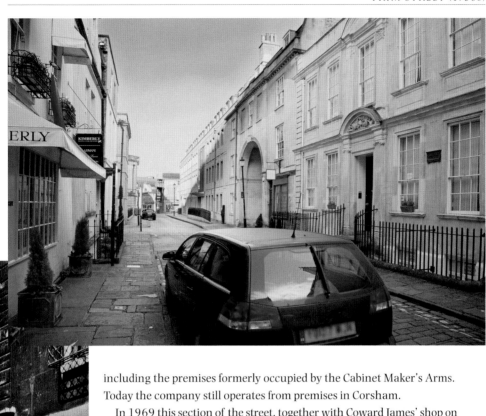

including the premises formerly occupied by the Cabinet Maker's Arms. Today the company still operates from premises in Corsham.

In 1969 this section of the street, together with Coward James' shop on the corner with Barton Street, was demolished to make way for a block that is representative of 1970s building in the city and is suitably unloved. The irony of the modern building is that until very recently it housed Bath's planning department, meaning that, for about forty years, people fighting to be allowed to make minor alterations to historic properties in the city faced having to deal with council officers working from a building sitting very uncomfortably in one of Bath's oldest streets.

St John's Gate was originally created in the north side of the street to provide access to Queen Square via Queen Street. Just this side of the gateway was Miss Ethel Brooks' confectionery shop. Then comes the street's most famous property, the ornate baroque façade of General Wolfe's house. Wolfe claimed a notable victory over the French in Canada and was known posthumously as the 'Hero of Quebec' when he died in battle in 1759. But it is said that he only ever lived here (in what was actually his parents' house) for a matter of months before departing to Canada.

On the left, the sign for W. Taylor & Son, Bookbinders is a reminder of times when it was common to have books bound to order, often to suit the colour scheme of a personal collection.

# CHEAP STREET (1937)

THE DECORATIONS ARE out for the 1937 coronation of George VI, this time captured in glorious colour via an early colour photographic process called 'Dufaycolor'.

Having swept down the High Street in front of the Guildhall, car No. 18 is bound for Combe Down and will turn down Stall Street, bound for the Old Bridge, carrying an advertisement for Harris sausages of Calne. The sausage company outlived the trams by nearly fifty years; Harris's closed in 1983 whereas the trams themselves were decommissioned just two years after this photograph was taken, in 1939.

The premises on the left-hand corner are empty following the closure of Fosters' store on this site and consolidation at their existing Stall Street branch, shortly to be replaced by Boots, who remained there for many years in what was known as 'Little Boots' when the 'Big Boots' opened in Southgate. Beyond Union Passage is Campbell's House Furnishers.

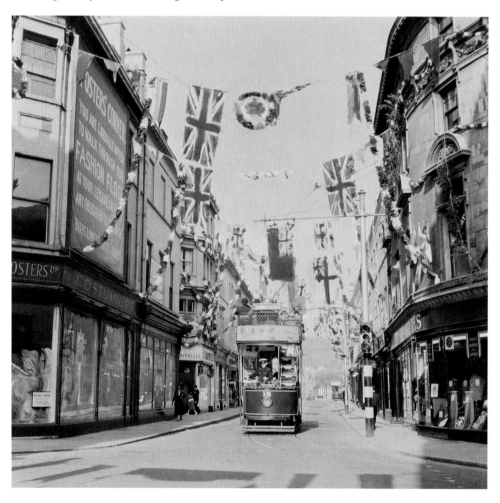

The patriotic window decoration on the right is that of Hepworth's gentlemen's outfitters and wishes the King 'Peace, Prosperity and Happiness'. The peace was not to last.

The traffic lights are testament to how the advent of mass motoring was leading to traffic congestion – this was a four-way traffic intersection at this junction at the time – and it is an issue the city has struggled with ever since. The lights in the picture are at green, but the scheme itself was not favoured with green lights. There was a battle to get the automated 'EVA' (electric vehicle-activated) lights installed at all. A trial EVA system at the bottom of Milsom Street in 1933 led to heated debate between the traders and the council, with the former claiming that their trade was being killed off by the 'unilateral waiting' (i.e. traffic light) system. From Milsom Street the lights quickly spread to other sites throughout the city, including Northgate, Charles Street and Lower Borough Walls, with the black-and-white striped posts (nicknamed 'EVA's sisters') going up at the Union Street / Cheap Street junction in 1934.

The situation at this spot today is eased by the pedestrianisation of Union Street and Stall Street, plus the one-way system operating on Cheap Street and Westgate Street. Yet it is still an absurd system that allows traffic to cross Bath's busy pedestrian thoroughfare with nowhere to go but to cross it again on Upper Borough Walls.

# STALL STREET /
# BATH STREET (1937)

THE BATH IMPROVEMENT Act of 1789 led to the widening of Cheap Street and Stall Street and to the new formation of Union Street and Bath Street, the latter so named as it formed a communication between the different baths. Thomas Baldwin's colonnaded frontages have drawn praise from major names in the field of architectural critique, including both Nikolaus Pevsner ('a perfect piece of design') and Walter Ison ('By far the most beautiful of Baldwin's street designs').

In 1909 there were proposals for a redevelopment of the block to the north of Bath Street as part of the Grand Pump Room Hotel, which would have led to major changes to the façade in the interests of providing more commodious facilities for hotel guests. The resulting protests spawned the Old Bath Preservation Society, whose campaign to retain the façade was ultimately successful.

In the 1980s, the northern side of Bath Street was again under threat after a massive fire in a block where developers wanted to realise plans for a shopping centre. They had faced massive objections concerning the listed status of the interior of the buildings.

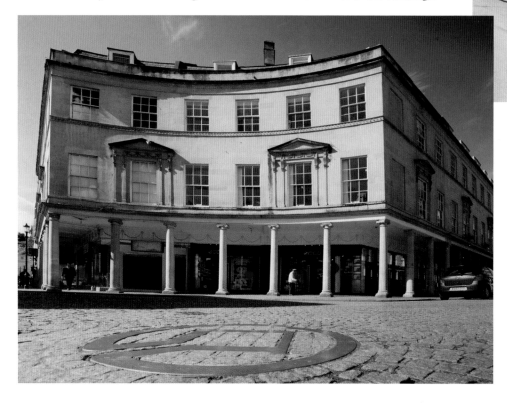

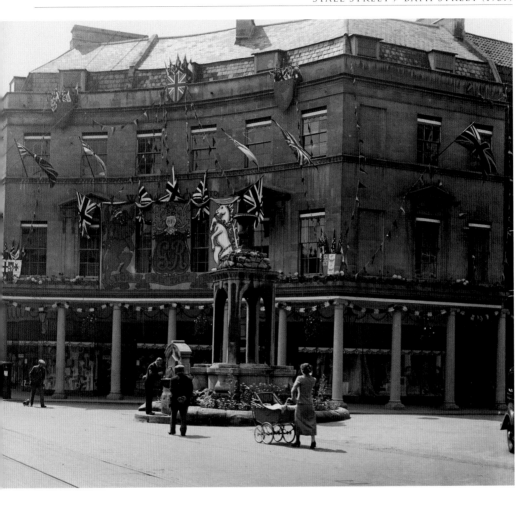

From the developers' point of view, it was almost too good to be true that the fire stripped out the interior whereas the façade was preserved. The shopping centre (The Colonnades) was built but lasted little longer than the fire itself and was soon replaced by a branch of BhS.

The mineral water fountain by Pieroni was erected in 1859 to replace an earlier fountain that had fallen into disrepair to the point where councillors claimed it had become little more than a repository for dead cats! As well as freely dispensing Bath's famous spring water, Pieroni's creation also provided a suitable focus for the alignment of Bath Street and for the curved bays at its end. It originally featured a statue of Bladud on the top, but at some point this was removed to the gardens of a Bath nursing home where it languished for many years before being restored and re-sited in Parade Gardens in 2009.

The fountain was later removed to Terrace Walk in 1989 after it was decided to mark Bath's 1987 proclamation as a UNESCO World Heritage Site, with the emblem inlaid in bronze in the ground.

The old photograph here is from 1937, with the streets generously decorated for the coronation of George VI.

# GRAND PUMP ROOM HOTEL / ABBEY CHURCH YARD (1937)

SURELY A QUIET day for Paisey's umbrella shop in Abbey Church Yard in the 1937 sunshine?

The Grand Pump Room Hotel opened in 1869 after replacing the famous White Hart coaching inn, which stood on this site. The White Hart had been a fixture in the coaching scene for centuries, occupying a large plot which fronted onto Stall Street. The inn had received a fashionable new façade around the turn of the eighteenth century in connection with the general Improvement Plan for Bath, which saw Stall Street widened. The most famous landlord here was Moses Pickwick, immortalised by Charles Dickens, who ran the inn in the early years of the nineteenth century. Trade dwindled after the arrival of the railway in 1840 and the White Hart closed in 1864, at which time the carved figure over its door moved to the Widcombe hostelry of the same name.

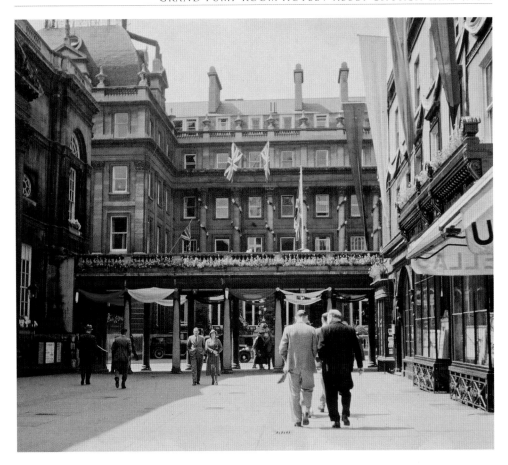

The demolition of the White Hart provided the opportunity for a thorough archaeological excavation in a site of massive interest for its proximity to the major Roman development. This unearthed part of the podium of the Minerva temple precinct.

The Grand Pump Room Hotel was built in a style reminiscent of a French chateaux and to a more modern formula (less stabling!), which included access to the thermal baths without having to venture outside, and a forecourt for guests to be dropped off by car. The main front steps were guarded by stone lions. When the hotel attempted to expand into Bath Street in 1909, the result was a lost battle with the preservationists and an amended scheme was adopted.

The hotel was popular throughout its existence, which came to an end when the Admiralty requisitioned the building in the Second World War. It was handed back in 1946, but the lease had been sold to the GWR in the meantime. With considerable uncertainty surrounding the future of the railways, it was never reopened as a hotel and was ultimately demolished in 1959 to make way for a development of shopfronts and thirty-three flats called Arlington House. The foreword by Jan Morris in Charles Robertson's *Bath: An Architectural Guide* is one of the most insightful pieces ever written about Bath. In it she writes of the 'flaccid inoffensiveness' of some of Bath's mock Georgian buildings, and Arlington House is surely a pinnacle of flaccidity!

# HIGH STREET, BATHEASTON (1910s)

THE JUNCTION OF Batheaston High Street with The Batch is at the centre of a village with more than its fair share of history. This is part of the old Roman Fosse Way, which soon turns left and climbs over Bannerdown. It is also the route of an old monks' path, built to serve as a link between the precinct in Bath and the monastic grange at St Catherine. The first recorded mention of this path is in 1669 and sections of the old causeway paving are in evidence in The Batch today.

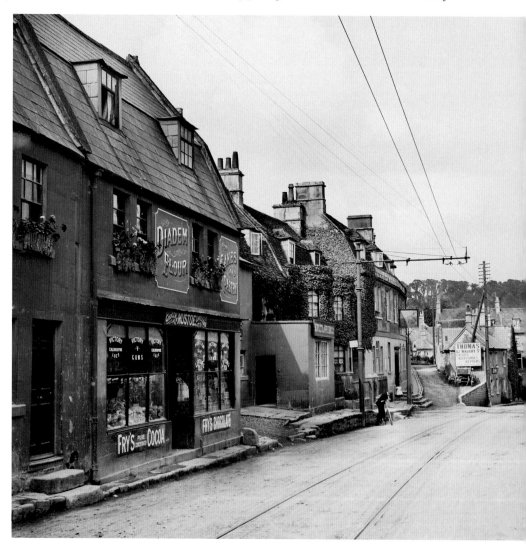

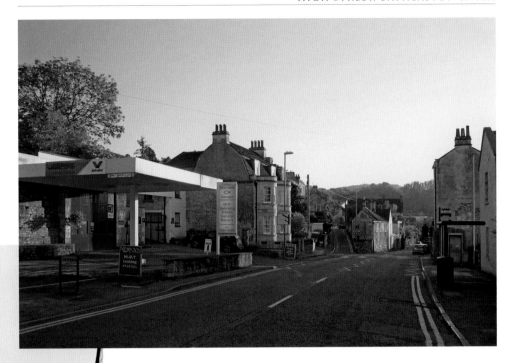

On 2 August 1784, you could have stood in this spot and watched John Palmer's first mail coach go by, on its way to London. And in 1904 the first electric tram to rumble through on its way to Bathford would have stopped at the white sign by the raised pavement.

For a considerable period of this time, the Lamb & Flag pub was at the heart of events, acting as a refuge for destitute travellers, a resting place for the deceased and a meeting place for Friendly Societies, which were popular around the turn of the twentieth century. It closed in 1962 and was demolished in 1968 to make way for a car park. Some of the pub's fireplaces can still be seen in the end wall of what is now Avondale, the house with the bow windows. Who knows what scenes those fireplaces saw!

On the left was Mustoe's general stores, now the site of Avondale garage, with Hewlett & Appleby (plumbers) beyond. At the junction with The Batch, there is also a large advertisement for Thomas's Walcot Street bicycle shop.

Batheaston's history is also closely linked with that of the suffragettes, with nearby Eagle House in Northend having provided refuge for leading activists of the time. A Mrs Tollemache of Batheaston Villa refused to pay taxes as long as she had no vote. Some of her goods were seized and auctioned at the White Hart, just out of view. They were bought back by supporters and a protest rally ensued in the street outside the Lamb & Flag.

Today the Batheaston bypass, built amid famous scenes of protest in the early 1990s, has brought relative peace to the village, and the white walls of the Elmhurst estate fill the distant view of the hillside.

# BATHFORD (C. 1906)

THE SIGN ON the tramline mast says 'Alight here for motor omnibuses' and this is exactly what is happening in this busy scene outside Bridge Farm. Passengers leave the Bathford-bound tramcar No. 28 in favour of a bus service heading out along the Box Road to one of the several destinations in west Wiltshire. The GWR bridge over the Bathford road juxtaposes an altogether faster form of transport with these fairly sedate options.

The bus bears the registration FB05, one of the earliest of the Bath-specific 'FB' registrations which, together with 'GL', were used for vehicles registered in the city for many decades, later with another prefixed letter in a set of three.

The owner of Bridge Farm at this time was a Mr William Harris, whose daughter Annie was successful as a pianist, performing on live radio broadcasts as early as 1926. William's own moment of fame had come and gone in the 1909 Bath Historical Pageant, a massive event involving hundreds of citizens in a series of displays and tableaux representing the history of the city. It is not known what role Mr Harris himself played in the pageant, if any, but it was he who, with the aid of trails of corn and a large muddy puddle in one his fields, spent many a

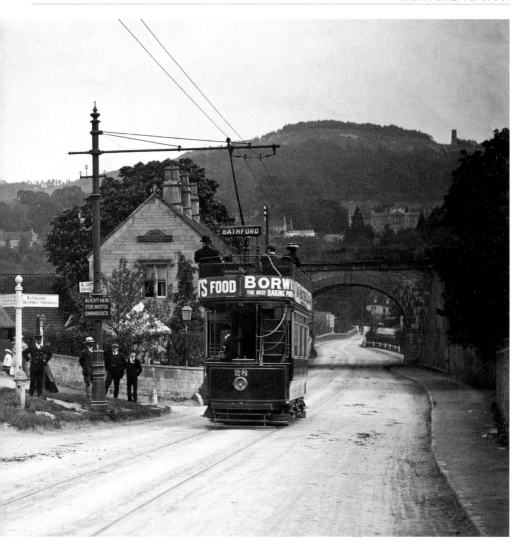

day training a herd of pigs to head unerringly for the mire. And they performed their part faithfully in front of crowds of thousands in a representation of the story of Prince Bladud, the swineherd who, according to legend, discovered the healing properties of Bath's thermal spring waters.

Brown's Folly, known as the 'Pepper Pot', can be seen on the skyline in the top right of the photograph, and the Georgian villa also called Eagle House looks down from its position near the church. On the right is a wall which once bounded the Quaker burial ground. This was the first burial ground for the Bath Society of Friends but was abandoned in 1836. Soon after, a plot was made available near Widcombe Crescent, where the Friends' burial ground still exists today, although burials are no longer conducted there. The burial ground in Bathford was subsumed into gardens after 1934, then partly demolished (along with Bridge Farm) in road improvements in 1979, before the 1993 Batheaston bypass obliterated the site completely.

If you enjoyed this book, you may also be interested in…

## Bath in The Blitz: Then & Now
DAN BROWN & DR CATHRYN SPENCE

In April 1942, Bath suffered enormous devastation at the hands of the Luftwaffe. Yet contemporary Bath bears almost no sign of this destructive period. With stunning archive images, and modern pictures by professional photographer Dan Brown, this book is a memorial to the city's sufferings and the bravery of its residents during the Second World War.

978 0 7524 6639 2

## Bath: City on Show
DAN BROWN & DR CATHRYN SPENCE

Talented local photographers have worked in all seasons developing this stunning portfolio of new and original views of Bath's most notable locations. These are presented with a pick of classic images of the city from the extensive archive of Bath in Time. From the Roman Baths to the Thermae Bath Spa, Bath has evolved to meet the changing needs and tastes of its residents and visitors.

978 0 7524 5674 4

## Water, History & Style – Bath: World Heritage Site
DR CATHRYN SPENCE & DAN BROWN

Bath is recognised for a number of Outstanding Universal Values, including its extensive Roman remains, its Georgian town planning that is documented as 'a masterpiece of human creative genius', its landscape setting, and the location of the only naturally occurring hot springs in the country. This book is richly illustrated throughout with historical images from the archives of Bath in Time.

978 0 7524 8814 1

## Bristol: City on Show
ANDREW FOYLE, DAN BROWN & DAVID MARTYN

This unique celebration of life in the city contains a stunning portfolio of new and original views of Bristol's most notable locations, all by local photographers. These images are juxtaposed with more than 100 of the rarest engravings and archive photographs of a city that is rich with Georgian splendour and architectural grandeur.

978 0 7524 7000 9

Visit our website and discover thousands of other History Press books.
**www.thehistorypress.co.uk**